HISTORY
of
DENVER

—⚯—

Elizabeth Victoria Wallace

The History PRESS

Published by The History Press
Charleston, SC 29403
www.historypress.net

Copyright © 2011 by Elizabeth Victoria Wallace
All rights reserved

Back cover: Stockyards in Denver. Leland Varain was the promoter of the rodeo, August 1926. *Courtesy of Betty Sala.*

First published 2011

Manufactured in the United States

ISBN 978.1.60949.350.9

Wallace, Elizabeth Victoria.
Hidden history of Denver / Elizabeth Victoria Wallace.
p. cm.
ISBN 978-1-60949-350-9
1. Denver (Colo.)--History--19th century. 2. Denver (Colo.)--Biography. I. Title.
F784.D457W35 2011
978.8'83--dc23
2011037318

Notice: The information in this book is true and complete to the best of our knowledge. It is offered without guarantee on the part of the author or The History Press. The author and The History Press disclaim all liability in connection with the use of this book.

All rights reserved. No part of this book may be reproduced or transmitted in any form whatsoever without prior written permission from the publisher except in the case of brief quotations embodied in critical articles and reviews.

Contents

Foreword, by James LaRue	5
Acknowledgements	7
Why They Came	9
On the Trail	19
People and Personalities	27
Prejudices	41
The Railroad Comes to Town	49
Businesses, Banks and Booze	53
Crime, Punishment and the Vigilance Committee	69
Sports and Recreation	79
Religion and Charitable Organizations	95
A Matter of Survival	103
Water Everywhere	109
Women of Denver	115
Did You Know?	135
About the Author	143

Foreword

The history of the West is the history of the footloose. Some were fleeing the law. Some became the law. Others sought fortunes and either gained or lost them—or both. The history of Denver—here encompassing 1858 to the 1940s—is a rich stew of colorful characters.

Who were they? Why did they come to Denver? And what did they do when they got here? Elizabeth Victoria Wallace's *Hidden History of Denver* is one look at those answers. The book includes stories from the descendants of those early settlers in which they describe the lives and dreams of their ancestors. Also included are rare and never-before-published photographs and sketches of gangsters, gypsies, rodeo stars and suffragettes.

The founding of Denver, like the founding of many western cities, is more about the ongoing reinvention of self than the discovery of one. And speaking of frontiers, this work represents another kind of reinvention: the independent local history, written by an experienced freelance author. As such, it represents an early settling in the still unexplored landscape of twenty-first-century writing. I recommend it.

James LaRue, Director
Douglas County Libraries
August 2011

Acknowledgements

I wish to acknowledge the following people and organizations for their help and assistance:

Denver Woman's Press Club
Denver Public Library
Pike's Peak Library District
Tallyn's Reach Library
Jessy Randell, archivist, Tutt Library Special Collections
Yorkshire (England) Records Office
Ted Tsumura
Audrey Ledgerwood
Roxanne O'Rourke
Paul Valdez
Susan and Rogers Davis
Maryann Rains
Betty Sala
Mary Ulmer
Georgia Garnsey
Carol and Leo Chiolero
Carol Smith Keller
Nedra and Don Werking
Cynthia Bronson
Joann Irvine

Acknowledgements

Ginny and Laurence Steele
Randy Varain
Mike Wooten
Joann Irvine
Bronson family
Shoates family
Neoma Jean Felton
Lieutenant Colonel Peacock
James LaRue
Wells Fargo in Colorado
Trinity United Methodist Church

The following publications/periodicals are most beneficial for such information on Denver's hidden history:

Italy in Colorado by Alisa Zahller
The City and the Saloon by Thomas J. Noel
City Smart Guidebook Denver by Georgia Garnsey and Hilary Garnsey
Communities of the Palmer Divide by the Palmer Lake Historical Society and the Lucretia Vaile Museum
Douglas County, Colorado: A Photographic Journey by the Castle Rock Writers
Smaldone: The Untold Story of an American Crime Family by Dick Kreck
The Roots of Prosperity: Littleton in the 1860s by Laurence W. Steele
Denver Post
Rocky Mountain News
Akron Weekly Pioneer Press
Empire magazine
Littleton Independent

Why They Came

During 1858, as news spread of the discovery of gold at the confluence of Cherry Creek and the Platte rivers, men came at first by the score, then hundreds and eventually by the thousands. Not everyone came for the gold. Some came to support the miners and their needs. Along with the gold-seeking pioneers came real estate moguls, saddlers, dry goods merchants, bankers and bakers.

After several years of continuous growth, one woman amused herself by counting the wagons that passed her property. Some were traveling east and others were traveling west, but in all she counted nine hundred wagons in one day! Other early pioneers noted that there were so many wagon trains crossing the prairie that one met the other and therefore formed one continuous train that stretched for almost fifteen miles. These were hopeful pioneers—with their most precious belongings packed into a Conestoga wagon, often with a set of bells atop the horses' or mules' headdresses, they headed west for a new life.

Originally, there were two small towns on either side of Cherry Creek. Denver (formally known as El Dorado) was situated on one side and was founded by William Larimer, and on the other side sat Auraria, given its name by the Russell party that comprised three brothers—William, Oliver and Dr. Levi Russell—and which was considered the more developed of the two towns, boasting twice the number of buildings.

The first white child born was a girl, to Mr. and Mrs. Henry Hubbell in the fall of 1859. The mother and child were given several town lots for their

Hidden History of Denver

Above: Many small businesses sprang up to accommodate prospectors' needs. They included dry goods stores, laundresses, barbers and, more importantly, cooks. *Courtesy Pikes Peak Library District.*

Left: Although not to scale, this circa 1858–61 map depicts the various trails to Denver City, the all-important rivers and springs and the places of trade. Bent's Fort, on the southeastern edge of the map, was strategically placed to maximize trading with various Native American tribes. *Courtesy Special Collections, Colorado College.*

enterprise in helping populate Auraria. The first nonwhite child born in what was to become Denver was William Denver McGaa, son of William McGaa and his Arapaho wife.

Naturally, competition was fierce as each town vied for business opportunities, but in the end they saw reason. On a fine spring evening in April 1860, the two towns became one during a candlelit ceremony, and Denver City was born.

Buildings sprang up at an alarming rate, with about 1,000 people living in roughly 160 homes. Some were built adobe style, others of log and frame, but none was painted. Watching with interest were the American Indians (Utes and the Arapahos) who for centuries had camped along the creek and knew its history. They warned the settlers not to build too close to the river—that the little trickle of water in Cherry Creek could suddenly become a raging torrent—but their advice was ignored. Only later did the pioneers realize their mistake as Cherry Creek flooded time and time again, with significant loss of lives and property.

At first, the Native Americans made the pioneers welcome, but as more settlers arrived, tensions rose. Nine members of the Ute tribe pose for the photograph, all apparently armed. One man (rear left) brandishes a rifle and a handgun. *Courtesy Special Collections, Colorado College.*

Kit Carson's map of the Kansas Pacific Railway, dated March 1870. The map is laid out to scale, with a notation "Limit of Survey" marked about halfway to Denver advising that the journey from Kansas City to Denver is 637 miles. Also included are stagecoach stops, creeks, rivers, Frank's Town (now Franktown) and the Twenty Mile House. *Courtesy Special Collections, Colorado College.*

During those early years, bartering was the main form of commerce, supplemented by the occasional pinch of gold, considered to be worth twenty-five cents. In 1880, the world's largest silver cache, weighing a monstrous 2,054 pounds, was discovered in the Smuggler Mine in Aspen.

In 1859, General George Breckinridge, with a few prospectors and investors, founded a town nestled in the mountains and went to work mining the area. It was not long before the town began to flourish, as more and more gold was discovered. An early requirement for any growing town is a post office. As part of the requirements, the town needed a name. It was decided to call the town Breckinridge after one of the original prospectors (it would later be changed to Breckenridge).

Less than thirty years later, on July 23, 1887, Tom Groves walked into town with a bundle in his arms. It was the largest piece of gold ever discovered in Colorado, weighing 13.5 pounds. Groves had wrapped his find in a blanket, and as he carried it to town, it looked as though he cradled a baby in his arms. Soon the nugget would be nicknamed "Tom's Baby."

Mystery and rumors have surrounded the discovery for more than eighty-five years, for no sooner had Tom made his fantastic discovery and placed it on a train to Denver than it disappeared. He must have been devastated.

At one time, there was so much low-grade ore produced that it was not worth the cost of processing, so it was used to pave the roads instead. This led newspapers to report that certain towns in Colorado were "paved in gold." *Courtesy Special Collections, Colorado College.*

During his lifetime, he never knew what had happened to his chunk of gold, where it was or who had captured his "baby."

In 1972, a concerted effort was made to find Groves's gold. Questions were asked at museums and banks, and finally the mystery was solved. It seems that while cleaning the gold, an employee at a museum accidently broke off a piece. Embarrassed by the blunder, the gold cache was placed for safety in a Denver bank, where it remained. However, almost five pounds were never recovered. Tom Groves's fantastic treasure is on display at the Denver Museum.

Rose Kingsley—daughter of the famed Charles Kingsley, author of *Water Babies*—visited Colorado often and watched with interest as valuable commodities were shipped by train and stagecoach. A keen observer, she described watching the stagecoach's driver in her diary:

> It is a sight I am never tired of watching: the coach with its four splendid bays standing in front of the office…the "messenger" stowing his mail-bags safely away; the passengers bundling in for a period of misery of varying length. When all is ready, and not until then, out walks the great man, in yellow coat, and hat securely tied down with a great comforter. He mounts the box, arranges himself leisurely; the messenger in beside him,

wrapped in buffalo robes; then the reins are put in his hand, and as he tightens them, away go the horses with a rush that takes one's breath away. The Western stage-driver, on his box, with the "lines," as they call the reins, in his hand, is inferior to no one in the Republic. Even the President, when he is on board, must submit to his higher authority.

The Climate

It was not only the hope of striking it rich that brought people to Denver from around the world, but it was also the desire to find a cure for the deadly disease of tuberculosis. During the 1870s, railroad magnate General William Palmer and his English cohort, Dr. Bell, bombarded the London newspapers promoting the curative air of the Rocky Mountains. It was not long before well-heeled men and women escaped the fog-ridden streets of London to make their way to Colorado Springs, then later to Denver. In fact, so many Londoners arrived in Colorado Springs that the town was dubbed "Little London."

"Wealthy Lungers," as they were often called, flooded to Colorado. Sanitariums were built, and when they were full, small individual heavy canvas tents provided emergency accommodation at about seven dollars per week. Later yet, small octagonal wooden buildings were built for the patients, who stayed an average of three to five months.

It was not only the clean, fresh air of the Rocky Mountains that the tuberculosis patients sought but also healthy food and plenty of rest and relaxation. Dr. Edwin Solly, an English physician, proposed an ambitious plan that included a nutritious diet, plenty of rest, sunlight and fresh air. He was also acutely aware of how important it was to keep the patients' morale high since most of them were alone, having left their families to seek a cure in Colorado. He encouraged friendship, visits from friends and letters from home. Dr. Solly noted:

> [A]*ctivity of the skin is increased…better nourished and strengthened; heart and blood vessels are probably strengthened; the number of respirations of the lungs is increased at the beginning of the stay, but returns to normal after a longer time; sleep is usually improved.*

Unfortunately, Dr. Solly died in 1906, and passed the mantle to Dr. Charles Fox Gardiner. Gardiner took the challenge in both hands. A

Dr. Charles Fox Gardiner designed small octagonal "tents" for those wealthy patients who could afford the exclusive housing. Other patients stayed in sanitariums or cloth tents at a cost of seven dollars per week; the average length of stay for maximum benefit was between four and five months. *Courtesy Audrey Ledgerwood.*

dedicated physician, he quickly realized that some of his wealthy patients did not want to stay in a large sanitarium. Instead, he designed the small octagonal cottages that could be rented for the duration of care.

The *Medical News*, a weekly journal of medical science, ran an article on Saturday, January 7, 1899:

> *It is a common experience to meet patients who after several years' residence in Colorado have returned to the East apparently cured, but who, after a short residence in New York, Philadelphia, Baltimore or other eastern cities, have again developed the disease and who have either died or been compelled to return to a high altitude.*

The number of tuberculosis patients rose dramatically in Denver from 1893 through 1898. Records from the Denver Health Bureau for those years show 2,588 registered deaths and that about 412 people contracted the disease.

At the turn of the century, it was believed that almost one-third of the population of Colorado had taken residence to seek a cure. Isabella Bird, an Englishwoman who traveled almost eight hundred miles through the Rockies, wrote to her sister, Henrietta: "The curative effect of Colorado can hardly be exaggerated. In traveling extensively through the Territory afterwards I found that nine out of every ten settlers were cured invalids. Statistics and medical works on the climate of the State (as it is now) represent Colorado as the most remarkable sanatorium in the world."

Dr. Florence Rena Sabin was born in Colorado City in 1871. Her father, like many other men who had poured into Colorado during the late 1800s, looked to make his fortune in gold. He was a hardworking miner who wanted the best for his daughter and so sent her off to Smith College, where she studied music. However, that did not last long because Florence set her sights on medicine and in particular medical research. She had a keen, inquisitive mind and spent many hours in the laboratory experimenting and researching. One of her first projects was a study of the lymphatic system. When the study was published, it was considered "the best scientific thesis written by a woman embodying new observations and new conclusions based on independent laboratory research."

Sabin did not return to Colorado for many years. In 1905, she joined Johns Hopkins Medical School, where she excelled. Later, she joined Rockefeller Institute for Medical Research, heading her own team. Her students loved her. One in particular noted that Dr. Sabin "cared so much

Dressed as a cowboy, Dr. Charles Fox Gardiner poses with a rifle and whip. Gardiner advised his patients to get plenty of fresh air, good food and ample sleep. Courtesy Pikes Peak Library District.

about my seeing the important points on the slide that she all but lent me eyes for the occasion."

Sabin retired in 1938, published her book *Franklin Paine Mall: The Story of a Mind* and then returned to Colorado. At seventy-six years of age, still feisty and full of courage, Dr. Sabin took on a new challenge that would lead her into the seedier parts of Denver. As head of the Denver Interim Board of Health and Hospitals, it was her responsibility to report on the conditions of the city, the trash that collected in the alleys, and the rats and other vermin that fed on it. She was also concerned about a new outbreak of tuberculosis, a disease that she had worked hard to conquer.

Sabin was a formidable woman of her time. She is well loved and fondly remembered by all who knew her. The *Denver Post* called her "First Lady of American Science."

On the Trail

For centuries, Native Americans had camped along Cherry Creek—given the name because of the small, choke cherry trees that grew along its banks. When the cherries were ripe, they were harvested, pounded and then dried in the sun to be used over the winter months.

Most Native Americans were peaceable; they shared and traded with the pioneers. But a few incidents caused havoc and distrust among the settlers. Tension steadily increased as more and more settlers arrived. Wagon and freight trains were attacked, with the freight and horses stolen. Men, women and children died, and ranchers began to fortify their homes. Since the men often had to leave the ranches on business, the women and children were trained in the use of firearms.

Just south of Denver on Route 105, close to Perry Park, stands the Benjamin and Mary Quick ranch. It was a favorite place for neighboring families to gather when hostilities were high, believing that there was safety in numbers. They were also drawn by the fact that the Quick house had been built of rhyolite, a natural stone quarried at nearby Castle Rock. It was a strong house, with a deep well that had been dug close to the home for convenience. Families felt safe and secure, nicknaming the ranch "Fort Washington." However, in reality, it was no more than a fortified ranch.

Just west of the Quick homestead lies a gently rising hill. Atop the hill is Glen Grove Cemetery, otherwise known as the Benjamin Quick Cemetery. Ben and Mary Quick had six children, only one of whom survived to adulthood. According to research by members of the Larkspur Historical

While traveling to Colorado to start the First National Bank in Colorado Springs, William Bangs Young sketched a scene of his campsite. The family could have taken a train, but since Mrs. Young had a heart condition, her family doctor advised her to take the slower route to give her heart time to adjust to the higher altitude. Courtesy Susan and Rogers Davis.

Society, some of the children from the Quick family were buried at the cemetery, including Susan, one year old, who died on November 23, 1866; Frank, fifteen, who died on October 27, 1868; and Niela, who died on March 10, 1869. Almost twenty-five other individual families are mentioned in the cemetery listing, including one reference to "Nuska," which perhaps was a favorite dog or other pet.

One Native American chief tried hard to keep the hostilities between the settlers and his tribe members to a minimum. Chief Ouray encouraged his people to be friendly toward the pioneers and to share the land and the buffalo. He was known as the "White Man's Friend" and was instrumental in peace treaties that were established in 1863, 1868, 1873 and 1880. He was also an accomplished linguist, speaking at least three languages; he died in 1880 in Ignacio, Colorado.

There are many stories about the Ute Indians and how curious they were about the settlers and, in particular, their food. Female pioneers thankfully recorded those incidents in their journals. Mrs. Young, a new bride and settler in the area, wrote that she had just made a batch of biscuits, the aroma drifting through the doorway and windows. She realized too late that she had accidentally doubled the amount of soda, making the biscuits inedible. Suddenly, a small group of Ute Indians appeared in the doorway, and Mrs. Young gave the supposedly inedible biscuits to her delighted visitors. She wrote that they appeared to enjoy her biscuits very much and happily went on their way.

Above: In 1861, Mary and Benjamin Quick and their family built a home south of Denver. They used rhyolite, a stone quarried locally, and they dug a well close to the house. During troubles with the Native Americans, families flocked to the Quick home for safety purposes. Local families nicknamed the Quicks' home Fort Washington. Ben and Mary Quick had six children, only one of whom survived to adulthood. *Courtesy Donald Wallace.*

Below: A large group of Ute chiefs in full, traditional headdresses of eagle feathers. Ute women sit on the ground in front of their men. The women of the tribe were known for their expertise in hide-tanning elk, deer and antelope. It was a closely guarded secret by the women, who produced the whitest and softest buckskin for their families. *Courtesy Pikes Peak Library District.*

As word spread of the hostilities, troops were sent to provide protection for the wagon trains. Even so, they could not protect everyone. Whole families were killed and some terribly mutilated, their goods stolen and their wagons burned. When telephone poles were erected, the Indians tore them down and burned them.

Not only were pioneers concerned about the Native Americans—who appeared without warning, stole horses and other livestock and then disappeared at will—but they were also worried about the conditions. So difficult was the journey from Lawrence, Kansas, to Denver that it was given the ominous title of Starvation Trail. Attacks from Native Americans were frequent, and as news spread of the skirmishes, homesteaders did whatever they could to protect themselves. A rancher by the name of Godfrey, who had built a business called Godfrey's Station, vigorously defended his property from a party of Indians. With the help of his family, who kept loading and reloading his guns, he was able to keep the Indians at bay. The Indians paid heavily for the attack, and many were killed or injured during the raid. They in turn nicknamed Godfrey's Station "Fort Wicked."

On the whole, the Native Americans were not troublesome to the pioneers, but occasionally there were sporadic incidents. There are stories such as that of the Macon family, who had an unfortunate incident on their way to Denver. When Virginia went to check on her baby son, she found the cradle empty. After making inquiries, Virginia and her husband, Thomas, went in search of their baby. They found him in the arms of a woman from the Ute tribe. She said she had taken him because he was such a fine boy. Virginia challenged the woman, told her that she was the rightful mother and asked her to give the baby back. The boy was handed over.

Not so lucky was Mr. Dietrich's family. Dietrich had traveled to Denver on business, only to return home to find his pregnant wife and young son murdered. Even though the woman and her son were scalped, it was generally believed at the time that some white men had carried out the attack because Mr. Dietrich was known to keep a large quantity of cash in the home. Evidently, the mother still held the hand of her five-year-old son as they lay dead on the ground; the young boy still had a little patch of hair over his right ear. Mr. Dietrich placed the bodies of his wife and son in his wagon, covered them and left for Denver immediately. On the way, the heartbroken man stopped at the Twelve Mile House and spread the word of his tragedy. Upon his arrival in Denver, troops were organized to search for the culprits, but the trail was cold and the murderers were never found.

Chief Ignacio of the Weminuche band of Ute Indians poses with his wife and child. Although Ignacio was a fierce fighter, he was also a gifted negotiator. He accompanied Chief Ouray as part of the delegation that traveled to Washington, D.C., to testify about the Meeker massacre. Negotiations failed, and legislation forced the Ute Indians into reservations. *Courtesy Pikes Peak Library District.*

supplies and provisions. After weeks and weeks on the trail, the four-mile stop provided a place where travelers could wash, change clothes and prepare themselves before entering the city.

In 1870, Levi and Mille Booth bought the property and expanded and improved it until they owned almost six hundred acres. Mille, like Mary before her, showed an interest in business. Even as the railroad reduced the amount of freighting and stagecoach stops that passed by their door, Mille went into the butter and honey business. At the height of production, she produced four thousand pounds of honey in one year.

People and Personalities

In 1858, Richens Lacy Wootton, who owned a freighting business, was following the South Platte River when he came across the area now known as Denver City. The air was thick with excitement after the recent discovery of gold, and the forty-two-year-old immediately caught "gold fever." He wasted no time and hurried back to his ranch in New Mexico. There he loaded his wagons with supplies, as well as a few barrels of liquor known as "Taos Lightning," and rushed back to Colorado. He shared the contents with the men of the town, and they in turn affectionately nicknamed him "Uncle Dick," perhaps for his generosity.

Wootton was a man who could turn his hand to almost anything. Born in Mecklenbery County, Virginia, his family moved to Kentucky, where he lived until he was seventeen years of age. It appears that he had a desire to travel, and so he joined a wagon train owned by Bent, St. Vrain and Company. During this time, he honed his skills as a trapper, hunter and guide. He was known to trade, barter and fight with the Native Americans.

Previously, Wootton appeared to enjoy the adventurer's life, traveling from Kansas City to California, San Luis Valley, New Mexico and Utah. He traded in sheep and cattle and experimented with animal husbandry by crossbreeding buffalos with cows. Denver City attracted him enough that he set down roots, built a house and sent for his wife. She arrived on Christmas Day 1858; only two other women preceded her, Countess Katrina Murat and Mrs. S.M. Rooker from Utah.

In 1858, forty-two-year-old Richens Lacy Wootton passed through Denver City with his freighting business. He returned that winter with two wagons of supplies, including his very own liquor he called "Taos Lighting." At Christmastime, Wootton opened the barrels and shared the contents with the men of the town. They affectionately nicknamed him "Uncle Dick," perhaps for his generosity. *Courtesy Paul Valdez.*

Wootton's new house was the first two-story home in Auraria and was nicknamed the "skyscraper." It was on the second floor of this building that the *Rocky Mountain News* came into being, under the direction of William N. Byers.

Mike Wooten (different spelling, but a descendant of Richens Lacy Wootton) provided the following:

> *R.L. Wootton's first wife of record was Mary Delores LeFevre. The census records we found indicated he married her in 1848 in Taos City, NM, but our research showed she died during childbirth in 1855 and was buried in Taos City.*
>
> *As the story goes, he had brought from Taos a few barrels of "Taos Lightning" whiskey and on Christmas day, shortly after arriving in the Denver area, he broke open the barrels and gave away free drinks all day. Someone threw out the name "Uncle Dick" for his generosity, and it just ended up sticking when he decided to stay and open his small general store. Uncle Dick's four marriages are on record, although sometimes when you cross check birth/death dates and census records, that information doesn't always match. There is no telling, based on the book, how many children and "wives" he had as he was purported to have fathered quite a few children via American Indian women as well.*

Wootton only lived in Colorado from 1858 until 1861. He led an exciting life and saw extraordinary things. He traded with the Native Americans and attended some of their ceremonies. He provided a valuable narrative as he described the Sun Dance of the Sioux:

> *They made preparations for the dance by attaching strong rawhide ropes to good-sized saplings, which were bent over until the tops came within eight or ten feet of the ground. When the time came for the dance to commence, an Indian took his place under each of the ropes dangling from the tops of the saplings, his body entirely naked above the waist. With a keen edged knife, two deep gashes a couple of inches apart were cut in the back of the savage and the rawhide rope was passed under the skin from one gash to the other. The rope was securely fastened and the Indian penitente, sometimes lifted clear off the ground as the sapling swayed back and forth, kept up a sort of rhythmic motion until the rawhide cut its way through the flesh and allowed him to drop to the ground.*

Over the next few months, a printing press was delivered in Denver, and William N. Byers, founder of the *Rocky Mountain News*, published the very first newspaper (volume 1, number 1) of the *Rocky Mountain News* on April 23, 1859. It was a historic moment for the fledgling newspaper, as Byers began:

> *With our hat in our hand and our best bow we this week make our first appearance upon the stage in the capacity of Editor. We make our debut in the far west, where the snowy mountains look down upon us in the hottest summer day as well as the winters cold; here where a few months ago the wild beasts and wilder Indians held undisturbed possession—where now surges the advancing wave of Anglo Saxon enterprise and civilization, where soon we hope will be erected a great and powerful state, another empire and sisterhood of empire. Our course is marked out, we will adhere to it with steadfast and fixed determination to speak, write and publish the truth and nothing but the truth, let it work us weal and woe.*

Another of the pioneers to settle Denver was fifty-year-old General William Larimer, of Pennsylvania, who named the town for Kansas territorial governor James Denver. Larimer was a colorful character who boasted of thirty successful saloons in the town. He would later say, "It was in that grove of cottonwood trees that I, myself, cut logs to build the first cabin on the town site of the City of Denver. Its place was made a corner,

and Samuel Curtis, from whom Curtis Street takes its name, and myself, staked off the four corners of what is now the intersection of Fifteenth and Larimer Street."

On the west side of Cherry Creek stood Auraria, a town growing at twice the pace of Denver. William M. Slaughter noted in his diary, "Just think that within two weeks of the arrival of a few dozen Americans in a wilderness, they set to work to elect a delegate to the United States Congress, and ask to be set apart as a new Territory! But we are of a fast race and in a fast age and must prod along."

One of the more colorful men to visit Denver was Jim Nugent, otherwise known as Mountain Jim. He was described as a "desperado" by some and "a quiet and very good man" by others. In 1873, the adventurer Isabella Bird revealed a tantalizing side to the man. She suggested that he was "chivalrous" to women and exceptionally kind, especially to children, noting that on at least one occasion he rode sixty miles to find a doctor for a sick child. He was an excellent scout, a true pioneer who lived alone and trapped bears, beaver and mountain lions. Dangerous with his pistols, the situation was always worse after a bout of drinking in the saloons. One saloonkeeper said of Nugent, "When he's sober Jim's a perfect gentleman; but when he's had liquor, he's the most awful ruffian in Colorado."

The death of Jim Nugent remains somewhat of a mystery, with several different accounts of his demise in existence. When Isabella Bird heard the sad death of her friend, she made inquiries:

> *The tragedy is too painful to dwell upon...Of this unhappy man, who was shot nine months later within two miles of his cabin. I write in the subsequent letters only as he appeared to me. His life, without doubt was deeply stained with crimes and vices, and his reputation for ruffianism was a deserved one. But in my intercourse with him I saw more of his nobler instructs than of the darker parts of his character.*

In 1880, just a few years after Isabella Bird's visit to the Rockies, the population of Denver and the surrounding area had grown to almost 36,000 people, with 194,327 in the whole state of Colorado.

Larry Steele is a fourth-generation Coloradoan. He earned his master's degree in history from Colorado State University and teaches Colorado history at the Community College of Aurora. His great-grandfather, Thomas C. Cowger, was an early pioneer in Denver and was a respected man known for his skill and ability in dealing with local Native American chiefs and

scouts. He was also a lucky man who barely escaped with his life on many occasions. In fact, he was nicknamed "the luckiest man on the plains" by some, "the man who missed many massacres" by others. Steele recalled a story passed down through the generations:

> *My father told me that after one of these skirmishes with Indians, his grandfather rode into town with two arrows lodged in his rear end… so who knows, perhaps there is some truth to the stories. My great-grandfather also had a sharp tongue and did not mince his words. When William F. Cody, better known as "Buffalo Bill"—world-renowned scout, buffalo hunter and the founder of Buffalo Bill's Wild West Show—died while visiting his sister in Denver on January 10, 1917, the authorities determined that his body should lie in repose at the state capitol. Following the announcement of the honor, six-year-old Joe Steele asked Grandfather Cowger for a favor. He asked his grandpa to take him down to the capitol to see the great frontiersman's body. Cowger himself, an early Colorado pioneer, refused and growled, "I wouldn't walk across the street to spit on Bill Cody. Now, on the other hand, if it was Bill Hickok that would be another matter."*
>
> *My dad never learned what animosity existed between his grandfather and Buffalo Bill Cody, but it seems likely that their paths had crossed somewhere on the Nebraska or Colorado prairies. Regardless, Cody was largely responsible for popular conceptions of the American West in the eastern United States and throughout the world. Like other great showmen of the late nineteenth and twentieth centuries, the truth of Cody's exploits were open to debate; however, his celebrity status was undeniable.*

Robert Shoates

Life for Robert Shoates in the early 1950s and 1960s was not easy, but even so he managed to rise from his position of railway mail clerk to becoming the first African American postmaster of Colorado in Littleton.

Shoates graduated from High School in West Virginia and enlisted in the air force in 1948. Later, he was sent to Colorado, where one of his duties was guarding the fence at Lowry Field. Shoates recalled:

> *You know, even on guard duty, where I was supposed to monitor and guard the fence at night, all I was given was a stick…the white men had guns.*

Robert Shoates became the first African American postmaster of Colorado in Littleton. Later, he was appointed to the position of manager of Motor Vehicle Registration by Mayor Federico Pena. "That was a real honor for me," commented Shoates. *Courtesy the Shoates family.*

We couldn't eat with the white guys, but I talked to my staff sergeant—he was a kind man—and he made it possible for me to eat at the same time.

When I joined the post office in 1951, I was earning $1.41 an hour as a railway mail clerk. I had to get the mail ready for a night pickup by train. The mail was placed in a leather pouch that had a chain attached. It was thrown quite a distance, and if I made a mistake, I would have been given a demerit. If I got more than 105 demerits a year, I could have lost my job. It was quite dangerous work, too, because the pouches were quite heavy. Anyway, I worked hard, did some classes by mail and others through DU, took the test, passed and became a supervisor.

As part of my job, I had to travel extensively. I traveled to Boston, Hawaii, Washington, D.C., and Kansas City. I was training people during the day, writing procedure manuals and curriculum for potential supervisors…and yet sometimes, I couldn't get a room for the night because of my color. There was a place in Kansas City, Missouri, that was always willing to accommodate me. That was the Streets Hotel, but in some other places, I had to sleep on the benches of the railway stations. You have to understand, it was a different time and place in our history.

I saw the advertisement for the position of postmaster for Littleton in the post office newsletter and decided to go for it. Although it was a huge responsibility, I really enjoyed the job. Another position I enjoyed tremendously was the manager of Motor Vehicle Registration. I was

appointed by Federico Pena, who was mayor of Denver at that time—that was a real honor for me, but I didn't stop there. Much later, three friends and I speculated on a land development proposal on a twenty-acre tract of land in Greenwood Village. We needed to raise $750,000, which was a lot of money even in 1983, and of course we had trouble getting a loan. In the end, a bank manager in Parker had faith in us, and we hired an attorney, builders, arranged for gas and water to be brought to the site and the whole project began. You know, I've done many things during my lifetime…and have always enjoyed the challenge.

Today, Shoates lives a quiet life in Denver with his wife, Marva. They have two children.

Joe Ciancio Jr.

When Joe Ciancio Sr. left his native Italy in 1900 to seek a new life in America, he could not have imagined how his family would prosper in their adoptive country. However, flourish they did, mostly through Joe Sr.'s accomplishments. He started his own business in a neighborhood market that thrived in the growing community and, in 1916, took on the responsibility of managing baseball teams. Later, he was recognized for his commitment, and a park at Fortieth Street was named in his honor.

In September 1901, Joe Sr.'s wife, Louisa Bruno Ciancio, arrived from Italy. They joined with other immigrant families and shrewdly acquired land, businesses, property and shops. The families helped one another, worked long hours and merged their entrepreneurial skills and business sense to provide well for their loved ones. As expected, families joined in marriage, too, and the Italian community prospered.

Joe Jr. was born in 1922, the youngest son to the Ciancio family in America. He graduated from Manuel High School in 1940 and was drafted soon thereafter into the army, in which he served in the U.S. Signal Corps. During his service, he traveled to India, Burma and China.

Ciancio was a tall, athletic young man who followed in his father's footsteps. He loved politics and sports, in particular baseball. Both would play an important part of his life, one as his career and the other as his favorite pastime. As a younger man, he played outfielder for the team of the Joe Albert men's clothing store in Denver. An ardent enthusiast of the sport, his passion has never ceased—he loves it still.

Joe Ciancio Jr. was born in 1922 to a very close-knit, hardworking Italian family. He realized at a young age that he had inherited the love of politics and baseball from his father. He chose a career in politics, a profession that he enjoyed tremendously, but it was his passion for baseball that has lasted his whole life. *Courtesy the Ciancio family.*

In 1955, Joe was first elected to city council and represented District 9. Over the following ten years, he served as president twice and in 1965 was appointed to the mayor's cabinet by Mayor Tom Currigan. He was the first Italian to hold such an important position, one that he held for eighteen years. While doing so, he became the manager of Parks and Recreation. Later still, he ran for the office of secretary of state but was unable to secure that position.

Ciancio enjoyed his job and loved to meet everyone who came by his office. He was privileged to meet Presidents Lyndon Johnson and John F. Kennedy. However, despite all his accomplishments over the years, he said, "One of the most rewarding things has been watching Denver grow. I'm glad that my family and I have played a part in its development and success." Ciancio recalls with a smile that when he took over the Denver Zoo, it was "little more than a small park housing a polar bear, a seal, and a coyote… and just look at it now!"

Joe Jr. and his wife, Rose, have been happily married for seventy years. They have lived in Denver all their lives and seen many changes. They have passed their community spirit on to their daughter, Pam Wright. Pam now presides over the position her father once held, that of the president of the Sons of Italy, a philanthropic group of like-minded people who reach out to the community at large.

Neoma Jean Felton, extended family member to the Ciancio family, reminisced: "If someone needed a loan, we never went to the bank. Instead, we'd go to someone in our own family, someone who was financially secure. That individual would provide the money, and a payment date would be established. No contracts were exchanged…in fact, I don't believe interest was even applied."

Neoma Felton (Neemie) and her descendants have lived in Denver and the surrounding areas for more than one hundred years. She continued:

> *There was a time when there simply were not enough men in our Italian community to marry our girls. Word was sent to Italy, and more young men came over. It was not unusual for a family to arrange a marriage, but of course that was a long time ago. We've come a long way since my grandparents emigrated from Italy in 1901. Seven generations of my family have lived and died in this city…and some of us still call it our home.*

Dennis Lee Bronson

Dennis Bronson was the only African American diver to graduate in his class at the U.S. Navy Ship Salvage School. He graduated on May 29, 1952 from class no. 41. His certificate reads that he "completed the prescribed course of diving 150 feet, and is qualified salvage diver."

Now eighty-four years old, he had moved to Denver in about 1954 when he joined the post office. Bronson remembered what it was like growing up in Horton, Kansas, during the 1940s:

> *Papa used to work long hours at the railroad. He provided well for my mother, sister and three younger brothers. Horton was not a big place, and there were few blacks in town, so we kinda kept to ourselves. Soon after I graduated from high school, I was drafted. My father, who had been in the army, told me the army was particularly hard on folks like us. Since I had to make a decision, I chose the navy instead, as did my three younger brothers. I went on to Fireman's School in San Diego and became fireman first class V-6 USNR-SV. I was stationed in Washington, Okinawa and the Philippines during this period. I did my four years, was awarded the Victory Medal and was also awarded an honorable discharge on August 2, 1946.*

Dennis Lee Bronson graduated on May 29, 1952, from the U.S. Navy Ship Salvage School. He poses center back with his classmates and is the only African American diver in his class. His certificate states that he "completed the prescribed course of diving 150 feet, and is a qualified salvage diver." *Courtesy Dennis Lee Bronson.*

I decided to return to the navy, but this time as an enlisted man. The year was 1950, and things had not changed very much as far as discrimination was concerned. I went to school and became a machinist's mate second class. I enjoyed the work and the challenge. I trained as a diver in San Diego and was the only black man in my class. After graduating, I was sent out to do the work I had been trained to do. Sometimes, we could repair the damage while the ship was in the water, but at other times, if the damage was too great, the ship would have to go into dry dock for repair. As part of our training, we had to dive to 150 feet to become a certified diver, but fortunately we didn't have to dive that deeply to do our work. It was hard and dangerous to get the ships seaworthy, but we managed with a combination of underwater repairs and some that were done on a small barge. That was one of the most common ways to do repairs out of the water. The barge held about ten men and their equipment. We had all the apparatus we needed, including an air compressor, wire cutting and welding gear on board. Once completed, the divers went down to replace the broken part. Occasionally, we were ordered to recover bodies, but I prefer not to think about those times…they are too painful.

In 1953, while I was on leave from Korea, I met Joalice, first at a Thanksgiving breakfast and then later at a dance. We hit it off immediately

and got married on August 6, 1955. Our two boys, Dennis and William, were born just fifteen months apart.

On January 27, 1954, I was given an honorable discharge, and I needed to find a job. I joined the post office first as a mail handler and later as a mail carrier. The pay was poor, but I felt fortunate to have a job. I often had to get up at 3:00 a.m. for my shift, and my wife used to get up with me. [Mrs. Bronson said, "Dennis would never take a sandwich to work—he liked a hot meal for his lunch, and of course there were no microwaves in those days. I used to put some stew or chili into a wide-mouth Thermos and off he would go in the early hours of the morning."]

WALTER CHEESMAN

Walter Cheesman, an astute businessman, arrived in Denver in 1860 looking to put his natural talents to work and invest in the new town. At first he started a drugstore and dabbled in real estate, banking and the

The construction of the Cheesman Dam was completed in January 1905. It was the creation of the Denver Water Union and its president, Walter S. Cheesman, who presided over the project. The amazing project took less than five years to complete. The caption on the original photograph reads, "Mr. Cheesman and family in boat." *Courtesy Denver Water Board.*

Two men assess the damage caused by the fast-flowing river. The ground below the railway lines has been washed away, leaving large sections twisted and buckled beyond repair. The men appear to be writing a report of the damage. *Courtesy Denver Water Board.*

Four unknown officials—one thought to be a railroad man in his bib overalls and hat—survey the damage as two rivers join and wash away the railroad tracks. *Courtesy Denver Water Board.*

railroad, but he finally set his mind on the water business. In 1894, he took the position of president of the Denver Union Water Company and tackled a particularly difficult project, the Cheesman Dam. The five-year project came to fruition in January 1905. It was once considered one of the most important water facilities in Colorado and boasted an almost eighty-thousand-acre-foot water capacity. The shoreline consisted of more than eighteen miles. Granite blocks, some weighing up to eleven tons, were used in the construction of the dam, which was nicknamed the "Million Dollar Dam."

The dam did not escape controversy. Local fishermen, who had fished on the South Platte River for many years, believed that the Cheesman Dam had taken away their livelihood. In September 1934, the water board published a pamphlet noting that "[t]he water needed from Lake Cheesman to replenish operating reservoirs in and about Denver usually is not sent down the Platte until dark on Sunday nights during the fishing season, so as not to hinder fishing in any avoidable way."

Another facility, called the Goose Creek Dam, was not so fortunate. That dam broke loose in the flood of 1900, causing tremendous damage to homes, businesses and railroad lines.

Prejudices

Although many people suffered from prejudices in Colorado, the Native Americans suffered a unique loss. They lost their land that they had loved and respected for centuries, and they lost their livelihood and food. They once said, "The white man has killed the buffalo and left them to rot on the plains…we will be revenged." They also lost much of their culture and heritage. They were lied to and cheated into signing treaties that were not kept. They lost their lives and were treated as something less than human, but not everyone felt the same way. Some early pioneers married into the Arapaho or Ute tribes, had families and led relatively happy lives. One adventurer commented:

> *The Americans will never solve the Indian problem till the Indian is extinct. They have treated them after a fashion which has intensified their treachery and "devilry" as enemies, devoid of the very first elements of civilization. The only difference between the savage and the civilized Indian is that the latter carries firearms and gets drunk on whiskey. The Indian Agency has been a sink of fraud and corruption; it is said that thirty per cent of the allowance ever reaches those for whom it is voted.*

The Chinese population of Denver also dealt with their fair share of intolerance and bigotry. About five hundred had stayed after the difficult completion of the Transatlantic Railroad, for which they had been paid little. They lived in makeshift homes or shanties clustered in an area called

"Hop Alley" located between Market and Blake Streets. On the night of October 31, 1880, a fight broke out between two Chinese men and two railroad workers. What caused the fight is not known, but the evening ended in disaster. A shot was fired, and although nobody was injured, a rumor was started that a Chinese man had shot a white man, and then a mob was on the loose, intent on justice.

Mayor Richard Sopris tried to get control of the crowd by calling for his police force. When members did not respond quickly enough, he called for the fire department's hose company. When the firefighters arrived on the scene and let loose a barrage of water, it only incensed the mob, and the people took revenge on a poor old Chinese gentleman who had not been involved. Sing Lee, who earned his living as a laundryman, was simply in the wrong place at the wrong time. The mob hanged him from a tree on Seventeenth Street.

Longtime Denver resident Carol Smith Keller recalled a time when her father took her to Hop Alley. She was a very young child at the time: "To this day, I don't know why he took me there because he was a very strict parent. Perhaps he took me to show me the other side of Denver, the opium dens and the like…to dissuade me, you understand, or to show me how other people lived. He held my hand tightly during the visit…it was something I have never forgotten."

When Japan declared war on the United States, life became very difficult for those Japanese immigrants who had made America their home, had viable businesses here and whose children had been born in America. Many Japanese

Governor Ralph L. Carr was a man of principle who, during World War II, stood his ground and refused to allow the Japanese people living in Colorado to be interned. Some say that the decision took its toll on his political career. *Courtesy Ted Tsumura.*

Americans in other states were forced into "relocation centers" for their own safety and well-being. In reality, these centers were little more than types of concentration camp. However, in Colorado, one man stood alongside the Japanese community: Colorado's governor, Ralph L. Carr, who would not have them interred.

At this time, Carr was in a close race for a seat in the Senate. Friends and associates tried to advise him to stand down from his commitments, but he would not. It was surely not for the relatively few Japanese votes. The race was run, and Carr lost. But in the loss, he endeared himself to many people. They loved him for his principled stand against discrimination, as well as his beliefs and dedication to all the people of Colorado.

In 1976, a bust of Governor Ralph L. Carr was erected in Sakura Square, downtown Denver. It reads:

> *In the hysteria of WWII, when others in authority forgot the noble principles that make the United States unique, Colorado's Governor Ralph L. Carr had the wisdom and courage to speak out on behalf of the persecuted Japanese American minority. "They are loyal Americans," he said, "sharing only race with the enemy." He welcomed them to Colorado to take part in the state's war effort and such were the times that his forthright act may have doomed his political future. Thousands came, seeking refuge from the West Coast's hostility, made new homes and remained to contribute much to Colorado's civic, cultural and economic life. Those who benefited from Governor Carr's humanity have built this monument in grateful memory of his unflinching Americanism and as a lasting reminder that the precious democratic ideals he espoused must forever be defended against prejudice and neglect.*

Other discrimination followed, with injustices against African Americans and Jewish and Polish settlers, each living in specific areas. African Americans clustered in what would become the Five Points Districts, the Jewish community gathered primarily on the west side of Denver and eastern Europeans mostly settled in the Globeville area.

Gypsies

Almost one hundred years ago, the once welcome gypsies who used to visit annually, bringing their expertise to local Denver, were chased away by law

enforcement. The *Akron Weekly Pioneer Press* reported that on August 15, 1913, a gypsy woman was put off a train:

> *Carrying three pots of meat and a dozen bulky bundles, and surrounded by her seven small children, Mary Adams, until a short time ago the queen of a gypsy caravan, was placed aboard a westbound train by deputy sheriffs. The woman's erstwhile husband, the deposed "king" from whom she was divorced a few days ago, tried to force his way into the car, but was thrown off by the officers. The gypsy woman carried with her $500 in money—her share of what remained of $1,120 taken from Adams' pockets when he was arrested in Colorado City after he had compelled his wife and children to get out of bed and dance for him.*

Carol Smith Keller, fourth-generation Denverite, recalled her parents talking about the gypsies who arrived in Greeley annually:

> *I can only speak of the gypsies that came to our town, but I suppose they moved on to Denver and other towns—after all, they were looking for work. Originally, I suppose they must have come in their wagons, during the early years, but later, during the 1920s, they came to Greeley in tumble-down cars and made an encampment on the north side of the Platte under the trees. My parents told me the gypsies came to town to do repairs, re-tin milk urns and other equipment that was used in industries such as bakeries and confectioners. They were obviously talented at their trade. They were also fond of dancing and used to have dancing contests at their camp.*

On July 21, 1915, the *Rocky Mountain News* reported:

> GYPSIES MUST GET OUT OF DENVER IN 24 HOURS
>
> *The crusade against fortune tellers, clairvoyants and other fakirs of that stamp in Denver made a decided advance yesterday afternoon, when Police Chief Duffield ordered virtually all the gypsies run out of the city within twenty-four hours. This included the gypsy palmists, trance medium, star-gazers and fortune tellers. The only member of this race exempt from the order are a few holding peddlers' licenses; and this exemption is only temporary. As rapidly as possible the licenses of these gypsy peddlers will be revoked, and the peddlers will also be ordered out of town. By 3 o'clock this afternoon, according to Chief Duffield, there will be only a handful of*

gypsies left in Denver. Gypsies found here after that time will be thrown in jail on charges of vagrancy.

Every year, during the summer, gypsies flooded into Denver. Some were hired to dig out the dandelions from the lawns on Capitol Hill, Speer Boulevard and the Country Club District. The more talented gypsies who specialized in coppersmith worked mainly re-tinning milk urns and repairing and refurbishing industrial equipment.

The *Little Independent* on July 13, 1923, reported:

A band of Gypsies stopped in the northwest part of Arapahoe County recently, near Federal and Alameda. Immediately they began making nuisances of themselves until the neighbors in that district were forced to appeal to the county authorities. Wednesday several were brought in by Sheriff Bennett and charged with being a nuisance and for disturbance and were fined $25 in costs and ordered to leave the county not later than Friday afternoon. The following Wednesday afternoon the Bell filling station at 29th & Lake Place was robbed of several dollars and Denver police immediately went to the camp of the Gypsies and arrested 3 women and two men and lodged them in the Denver jail, charging them with the robbery. These roaming tribes make their living by telling fortunes and stealing and the only way to deal with them is to keep them moving. There are about 100 in this band and all are travelling in high powered machines.

Over the years, the police and the Better Business Bureau have warned residents about bands of gypsies who suddenly appear and offer to paint a house or barn with a "new brand-name product" that is basically useless or who swarm in groups going door to door selling what they call their own prized linen or lace products from "the old country" but in reality is just regular merchandise.

Periodically, the *Denver Post* and the *Rocky Mountain News* reported incidents involving gypsies. Mr. Den Bell, of the Better Business Bureau, warned in the *Denver Post* on August 31, 1954: "They're out to peddle their wares by swindle. On the first contact, call the BBB or the police."

Almost annually, there were negative reports about roaming "gypsies" who tried to bilk residents by selling "luxurious furs" or offering to blacktop the driveway (with nothing other than crank grease oil that washed off in a heavy storm) or give palm readings. How many of these were actually real gypsies or simply people imitating gypsies is hard to tell. The police

In 1970, the "Gypsy Queen" Katherine Marks was buried at Olivert Cemetery. More than two thousand family members and friends attended the burial; some of them had traveled from Europe to pay their final respects to the woman they considered queen of the gypsies. According to Katherine's wishes, the band Reign played at her funeral. *Courtesy Denver Public Library.*

sent undercover policewomen into the city armed with marked money. Immediately, the officers were accosted on the streets and asked for money in return for the palmist to tell their fortunes. One policewoman said that a young gypsy woman, no more than sixteen years old, offered to read her palm for five dollars. When the officer told her that she only had three dollars on her person, the gypsy said that she would accept that amount but that the woman needed to return the following day with eggs, a pound of coffee and a pound of sugar.

In 1970, the "Gypsy Queen" Katherine Marks died at the age of 102 years. According to the *Denver Post*:

> *Gypsies from through the United States and several foreign countries had begun arriving in Denver for Catholic services and a Gypsy burial*

procession Wednesday and Thursday. Mrs. Marks, whose legal name was Markovwich, was born in Russia July 1, 1868. At one time, she had fortune reading shops in the 1700 blocks of Larimer and Curtis Sts.

Her body, garbed in a traditional Gypsy costume, is lying in state at Noonan Mortuary…eight relatives and close friends are conducting a round-the-clock vigil at the mortuary…A spokesman for the mortuary said he had received calls from all over the United States asking about services… and that the mortuary had an automobile standing by to pick up mourners at Stapleton International Airport as they arrive.

William Gallo of the *Rocky Mountain News* reported on October 9, 1970:

The queen of some 2,000 members of the Marks Gypsy Tribe from the United States and Eastern Europe, Katherine Marks has no ordinary funeral, and the 200 tribal members who came to Denver did not forget the leadership she had rendered since she took the royal reins after her husband's death in 1944. Katherine went to her rest with a spinach garden of dollars laying across her bodice and twined through her waxen fingers ("traveling money," one family member said).

According to Katherine's wishes, the rock band Reign played "Son, There's a Smile" as the casket was carried by her grandsons. It was a regal affair, with Lincoln and Cadillac cars snaking the mourners to Olivert Cemetery. Gallo's article continued: "The casket was again opened at the gravesite…Then, slowly, the family started to file by the casket, each person stooping to kiss the lips of the deceased queen. Men, women, children all filed past…many weeping, some stopping to arrange the dollar bills between their queen's fingers."

The Railroad Comes to Town

The maiden voyage of the Denver and Rio Grande Railway took place on October 26, 1871. It was just one of the dreams the founder, General William J. Palmer, had envisioned for Colorado. As engineer in charge of the Pennsylvania Railroad, he watched and learned the benefits that a railroad could bring to a state. He also saw the negative side of the business. First, the trees were felled for railroad ties, leaving a swath of nakedness through an otherwise beautiful terrain, and secondly, he estimated that sixty thousand cords were burned to operate the railway each year. An ecologist at heart, Palmer knew that something had to change before all the trees were devoured, and a new idea was forming even as his new, three-foot narrow-gauge railway, nicknamed "Baby Road," made its debut.

On October 26, 1871, the *Rocky Mountain News* reported:

> *The train was composed of a baggage and smoking car and two elegant passenger coaches, Denver the name of one and El Paso the other, drawn by the engine Montezuma. The train left Denver at 8:00 this morning. A pleasant run was made to the terminus of the road at Colorado Springs on regular time, all the guests enjoying the magnificent scenery along the line and being highly pleased with the excellent manner in which the road had been constructed…arriving at Colorado Springs at 1:00 o'clock, the excursionists were joined by General W.J. Palmer, the distinguished President of the Denver & Rio Grande Railway, and Ex Governor A.C. Hunt, and sat down to a splendid dinner…[A]fter dinner, carriages were*

The Montezuma engine weighed almost twelve tons, small for an engine during the early 1870s. It was built by the Philadelphia Baldwin Company. General Palmer and several important dignitaries filled the carriages for the maiden voyage. *Courtesy Special Collections, Colorado College.*

> *provided and under lead of General Palmer the party drove over the new town site of Colorado Springs up to the valley of Monument Creek, across to Colorado City, through the Garden of the Gods and up the Fountaine-Qui-Bouille to Villa La Font where the party rested for the night.*

General Palmer had accomplished one of his dreams: to build a narrow-gauge railroad. Then he turned his attention to his next project, building a spa town south of Denver. While traveling on a train, he met a young girl named Mary (Queen) Mellon, who was traveling with her father. Palmer was immediately smitten with the young woman, who was said to have the "voice of an angel." A courtship followed, mostly by mail, and later the two were married in her hometown of Flushing, New York, on November 8, 1870.

Palmer impressed his new bride with his plans to take advantage of the "wealthy lungers" from the East Coast, England and mainland Europe who flocked to the Rockies for their health. He purchased ten thousand acres south of Denver in the vicinity of Colorado City. He named the new town Colorado Springs and set about platting the town with wide, tree-lined streets. The wealthy men who made their fortunes in the gold and silver mines of Colorado spent their money building beautiful houses in Colorado Springs, but not all went smoothly for the Palmer family. His young wife suffered a heart attack while visiting a friend in Leadville and was advised

General Palmer, railway mogul and businessman, leased Ightham Mote, a medieval home in England, for his wife, Queen Palmer, and their daughters. His wife had a heart condition, and her doctor recommended that she live at sea level, but why she chose to leave America and live in a foreign country remains a mystery. *Courtesy Robert and Evelyn Gladstone.*

to live at a lower altitude. Mary decided to not only leave Colorado but also travel to England, where she and William had honeymooned. Why she would travel so far to live at sea level is still a mystery. General Palmer visited England at least twice a year, and on November 12, 1881, Marjory, their third daughter, was born in England.

For a while, Queen Palmer lived in Ightham Mote, a medieval manor house. Originally built in the thirteenth century, it had been expanded and renovated over the centuries. Palmer complained in letters to his wife that he feared that the house was "cold and draughty," but Queen responded that it was "not draughty" and that she and the girls loved the ancient home.

Queen and her daughters moved three more times in England, and Queen died in the last home, in Frant. Elsie, the couple's eldest daughter, had notified her father that her mother's health was deteriorating; however, even though the general left Colorado Springs immediately, he did not arrive in time to be at his wife's side at her death. She died on December 27, 1894, at the age of forty-four years, having lived half her married life apart from her husband. General and Queen Palmer now lay together at their raised plot in Evergreen Cemetery, Colorado Springs.

Businesses, Banks and Booze

The Gully Ranch

Years after the "Great Irish Famine" and the starvation of 1 million people, Thomas and Temperance Gully, as well as their four children, boarded a ship in Ireland as steerage passengers to America. They, along with almost 1 million other Irish pioneers, left their homeland for a better life in a far-off country. The journey took almost four weeks, much of it below deck with many other families. The crossing could not have been easy, but it must have been an exciting time for the Gully family.

At first, the family lived briefly in New York, but like many Irish pioneers before them, they decided to go west. They settled in Leadville, hoping to take advantage of the mining industry, but it did not suit Thomas. He had dreams of owning his own ranch and breeding horses.

After much consideration, he decided to claim (Colorado was still a territory at this time) 11,500 acres at the junction of Mississippi and Chambers. He chose the location because of the lush meadows and water that flowed periodically in Toll Gate Creek; however, the family prayed for the underground spring to come alive. Thomas quickly went to work. He built a dugout in the side of a hill, then a log cabin and finally a shed for their stock. The skills he had learned as a young man in Tipperary served him well in America. Growing up in the countryside of Ireland, he had been trained in the art of animal husbandry. He put that knowledge

to good use and starting breeding horses. He began with a combination of Morgan and mustang horses, breeding and crossbreeding until he was happy with the outcome. The end result was a strong, durable animal with a good disposition. Soon his horses were in high demand for freight lines and product delivery for businesses such as the Tivoli Brewery. John Gully registered the "Flying T" brand on December 27, 1899. The "Diamond Bar" brand was registered by his wife, Elizabeth, on December 30, 1899.

The Gully family would indeed see their wishes for "live" water realized. Mother Cabrini, a frequent visitor to the ranch seeking donations for the "Queen of Heaven Orphanage," changed everything. Mary Ulmer, a descendant of the Gully family, recalled her grandmother Mary's (Mamie) story of a strange event: "It happened during one of those visits when Mother Cabrini called in from 1902 to 1912. After visiting with my family, Mother Cabrini asked for directions to the Kennedy ranch. My grandmother climbed in the wagon to direct her. As they crossed the creek, Mamie told

The descendants of the pioneer family of Thomas and Temperance Gully started a rodeo in the mid-1940s. Betty Sala still remembers posting the advertisements all over town. The cost was about two dollars per family for an all-day event. *Courtesy Mrs. Betty Sala.*

Hidden History of Denver

Above: The servicemen from Buckley Air Force Base walked south across the fields dressed in their uniforms to enjoy the rodeo at the Gully Ranch. *Courtesy Mrs. Betty Sala.*

Below: Spectators crowd on the fences during the 1940s Gully Ranch rodeo. Cowboys used specific types of horses for a particular task. For instance, a "cutting horse" was used for separating cattle, and a "roper" was good for riding while lassoing. *Courtesy Mrs. Betty Sala.*

Here are some things which Mrs. Sweet said in her Christian Science lectures at mother's which I think are very beautiful.

"Do not talk of the faults of others, they do the best they can.

"Do not talk of the faults of children, as it does not help them to overcome their faults.

"See the good and speak of the good in every one rather than the evil; if we think hard thoughts of others we throw stones at them.

"Do not find fault with yourself, you are a part of God.

"Keep God's love burning in our hearts, this most of all."

Thursday, July 8th 1892.
About a month ago George, Jessie and Herbert and I went to Denver, we went to look at some lots that Sinton Bros. own in North Denver. We had a fine time looking around the City. We went to Berkley Lake—and Manhattan Gardens to see the Animals. We all enjoyed it very much. North Denver is a beautiful part of the city; there are so many trees. The vicinity where our lots are is called Highland Park.

Wells Fargo & Company

In 1852, Henry Wells and William Fargo joined forces to the start the Wells Fargo Company. Their first office was located in San Francisco during the gold rush, but when gold was discovered in Colorado, they quickly turned their attention to the Rocky Mountain region.

Wells Fargo was proud of the service it offered to businesses and the public. Gold, silver, mail and express shipments were sent via its custom-designed stagecoaches that were built for comfort and speed. Mark Twain appears to have enjoyed his journey in one and described the stagecoach as "a cradle on wheels." But not every passenger was happy. In 1865, Demas Barnes, a passenger en route to Denver, complained: "A through ticket and fifteen inches of seat, with a fat man on one side, a poor widow on the other, a baby in your lap. A bandbox over your head, and three or four more persons immediately in front leaning against your knees makes the picture, as well as your sleeping place, for the trip."

During the height of the gold rush in Colorado, miners found gold dust an inconvenient medium of exchange. It was obvious that a banking system was needed, and it came in the form of three entrepreneurs from Lawrence, Kansas. Brothers Milton and Austin Clark and a third man, Emanuel H.

Gruber, established an assay office and a bank in Denver. They also brought equipment and machinery to mint gold coins.

In 1860, the gold coins produced at the Clark, Gruber and Company became the chief medium of exchange in the Colorado Territory, and Clark, Gruber remains the only commercial bank ever to strike its own coins.

Wells Fargo temporarily withdrew from Colorado in 1875, but the advent of the railroad rekindled its interest, and offices were built all along the railroad lines. The Denver office was opened on July 1, 1882, and pledged to the public that "[s]ervice is the very backbone of the express. Our merchandise is courtesy, willingness and human ability."

Booze

The European, English and Irish tavern owners of Denver in the mid-1800s were a far cry from their counterparts at home. There the landlords would invite a customer to enjoy a tankard of beer in the saloon or the private bar or perhaps a genteel tipple in the lounge. He might be offered pickled herrings or eggs kept in glass jars on the counter, a board game such as nine man morris, cribbage or chess. Working-class men could wash down a meat pie or pasty with a pint of the landlord's best bitter, but in Denver, things were different.

The Chiolero jug was unearthed in 1948–50 during road construction of the Valley Highway (now Interstate 25), which was located between Thirty-eighth Avenue and Alameda. Fortunately, it was not damaged in the process, and the Chiolero family was contacted. The jug reads, "P. Chiolero, Wholesale Liquors, Denver, Colorado." *Courtesy Carol and Leo Chiolero.*

In 1860, there were almost forty saloons vying for business, and competition was fierce. Since many of the saloonkeepers were from Germany, Austria and England, they brought many of the customs and traditions from their homeland. Beer gardens became popular, as well as games such as billiards, during which men could have a drink and perhaps a cigar.

Said Betty Sala, whose great-grandparents owned the Gulley Ranch at the junction of Mississippi and Chambers:

> *It was a way of life for most men. They finished a hard day's work and headed for the saloon. That's what they did in those early years. I remember stories from my family where my great-grandfather used to visit the "Corner" of Larimer Street. That area didn't have a very good reputation in those days…but I don't suppose my great-grandmother could do very much about it—that's just the way it was…my great-grandfather was a very colorful character.*

Isabella Bird, an English adventurer who visited Denver in 1873, wrote to her sister in England: "[T]he number of saloons in the streets impresses one, and everywhere one meets the characteristic loafers of a frontier town, who find it hard even for a few days or hours to submit to the restraints of civilization…whiskey is significant of all evil and violence."

Although Bird's comments appear to be a little harsh and judgmental, there seems to be some justification for her bleak criticism. In 1859, the town boasted 31 saloons; fifteen years later there were 48, and thirty years later yet, there were 334 saloons. What is significant about Bird's commentary is that she often makes derisive remarks about the men of Denver, citing their bad language, drinking habits and dress, but rarely (if at all) complains of being molested or treated poorly in any way.

One of the more influential beer-producing companies in the city was the Zang Brewing Company. Philip Zang took ownership of the South Platte Hotel in 1877 and put his best bartender, Charlie Walbrecht, in charge. To guarantee that the meals would be of the highest quality, he sent his personal cook, Mata, to help run the culinary side of the business. The hotel was a success under Charlie and Mata's management, and it made money for Zang. To be sure that the hotel had fresh food, Zang arranged for a special "fish train" to run on the weekends.

A saloon was the place for men to drink, eat and share information. The innkeepers were usually well-informed local men who could advise a traveler on just about anything—from a place to stay to a woman or a cigar.

Cigars were big business in Denver. The majority of men smoked a pipe or cigar, and this did not go unnoticed by some astute businessmen. Many had been successful in the mining or railroad industries, but then they turned their attention to the lucrative tobacco industry. In fact, there were so many such businessmen that they formed the Journeymen Cigar Maker, Local Union No. 129.

It appears that cigar making flourished throughout Colorado. The *Aspen Daily Chronicle* reported on September 17, 1888:

> *Another feature of the business life of Aspen has been inaugurated, and it is located at 509 Cooper Avenue. At this place Mr. T.B. Wilmeth has opened a neat establishment for the manufacture and sale of cigars. A telegram from Denver to-day is to the effect that four cigarmakers for the new factory leave Denver for Aspen tonight…..Mr. Wilmeth is a genial gentleman and, what is nearly as good, a hard-shelled democrat. A sample of his imported Havannas convinces us that he has brands that it will do our merchants and consumers to examine.*

In fact, cigar making turned into a cottage industry. The *Greeley Tribune* reported on August 8, 1901:

> *While trusts are multiplying and the centralization of capital in all business is accepted as one of the inevitable conditions of the day, there is at least one business, cigarmaking, in which small capitalists can engage, says a New York cigar manufacturer. With a capital of $25.00 any cigarmaker can start in business as a manufacturer and while he may not be rich, can make a living. There are at least 2,500 cigar manufacturers in New York who work as journeymen when there is no demand for their services, and by the expenditure of a few dollars become manufacturers when work is slack. All that one of these small manufacturers needs in order to start in business is a few pounds of "wrapper" leaf, the same of "filler," and pound or so of "binders" and skill. He will have to get bondsmen, as each cigar manufacturer must have two securities in $1,000 each before he can get a license, but there is no difficulty in securing the bondsmen.*

The *Colorado Transcript* reported:

> Dollars Sent Outside Are Forever Lost to View
>
> *On various occasions the Transcript had been able to inaugurate a "patronize home industry" campaign that has attracted active interest and*

been beneficial, for a time at least…every dollar you spend for articles manufactured in your home town helps just that much toward furnishing employment for more workmen. More workmen, more families; more families, more supplies necessary, more business for merchants…Think of this when you contemplate having a wagon made, buy a loaf of bread, brick for a house, or a cigar, have laundry work done—whenever you are about to spend money, see if you can't spend it where it will actually benefit you long afterward.

The *Fort Collins Weekly Courier* dated December 13, 1912, had an article that described small businesses and what an individual can do to make a living:

Let's boost the Industries we already have…For a starter we wish to tell you about one that should have more support and if it did, would bring more well-paid men with families than any other without our immediate reach. This industry is cigarmaking. Some time ago the writer visited a city of some 12,000 people and among the many little factories pointed out by the boosters was a cigar factory. It employed thirty-five operatives, besides a

Fourth-generation Denverite Leo Chiolero's great-grandfather, Peter Chiolero, started several businesses in Georgetown and Denver, including a cigar and importing business. The image of Peter Chiolero can be seen on the highly decorative cigar box. *Courtesy Carol and Leo Chiolero.*

force of probably 10 more who did the packing, shipping and etc. All in all there are about 50 cigarmakers in that city. In Fort Collins we have about 12 cigarmakers producing about 1,000,000 cigars per year. Just think what it would mean if we would boost home-made cigars to the point where we would have to have 50 cigarmakers! That would mean 38 new families at a daily income of not less than $3.00 per day.

Fourth-generation Coloradan Leo Chiolero wondered what life was like for his ambitious great-grandfather, Peter Chiolero, when he set foot in Georgetown in 1880:

Most people came to America with little money in their pockets, and I'm assuming my great-grandfather was no different. They all came with a dream but never left their responsibilities behind. Peter Chiolero had had a bout of yellow fever while working as a miner in South America, but he still returned to Italy to fulfill his obligations to the Italian military. In 1880, he married my great-grandmother, Catherine Trione, and they moved to the silver-rich mountains of Georgetown. At first, he dabbled in mining, but it was dangerous and backbreaking work. Soon, my great-grandmother gave birth to Joseph, who was quickly followed by Stephen and Laura.

The following year, my great-grandfather took a partner, Joseph Kerschenbaumer, an emigrant from Austria, and opened the Little Casino saloon and boardinghouse. For a few years, things went smoothly, until a particularly harsh winter hit, and the economy suffered. Then there was some kind of argument or fight in Georgetown—I don't know the cause or what happened—but whatever it was, the decision was made to move to Denver. Once in town, he teamed up with Gian Battista Cunio, and they started a cigar and importing business. That business must have been quite profitable because other partnerships followed, including Cajal and Chiolero, Vola and Chiolero and P. Chiolero and DeSilvestro. Great-grandfather must have been quite the entrepreneur because he struck out on his own in 1905, establishing the Chiolero Importing Mercantile Company, as well as several other businesses.

Denver Artists

They were called "wall dogs" because they worked on walls and worked like dogs. The derisive term did not appear to concern the men who were part artists, part daredevils and, most of all, part chemists. Instead, they

let their work speak for itself. Some of it can still be seen on the streets of Denver to this day, a testament to the quality of the work. The art of wall painting has been a popular way to decorate, advertise and promote for thousands of years. Roman artisans painted murals on shops walls, homes and bathhouses, advertising their wares and services.

On April 19, 1863, a terrible fire destroyed almost every wooden building in Denver. The people decided that it was time to take affirmative action, which came in the form of a "Brick Ordinance" that ordered buildings to be built of brick or stone. The ordinance was drafted into law the day after the fire and remained there until the middle of the twentieth century.

New buildings sprang up with large, bland brick walls, which became natural canvases for sign painters. One of the first to take advantage of this relatively new brand of advertising was James A. Curran. In 1883, after spending three years building a lucrative sign painting business in Leadville, Curran moved to Denver and started the Curran Bill Posting and Distributing Company. He was an astute businessman who knew from experience that there was potential for growth in outdoor signs. His became the most influential sign painting company in town, and therefore the best sign painters flocked to join his company. His business was not limited to Colorado; indeed, he sent crews of his men to neighboring states such as Wyoming, Utah and New Mexico. The men painted signs on shops, barns and carriages.

The phrase "wall dogs" is a somewhat derogatory name used to describe men of considerable talent, experience and bravery. Their work can still be seen on the brick walls of Denver Streets, such as at the Brecht Candies company, with the motto "Makes Life Sweeter." It is located at 1333 Wazee. *Courtesy Donald Wallace.*

They painted on wood, glass, brick and metal. In fact, they painted whatever was needed on almost any surface.

Curran was an entrepreneur at heart, constantly looking for ways to improve the business. He was the first man to use billboards advertising everything from shops to circuses to political candidates. At that time, Robert A. Speer was running for mayor. While the newspapers were not kind to Speer's campaign, Curran assigned twenty of his employees to paint billboards, changing the messages daily to help Speer get elected.

Wall sign painters were by nature gregarious and outgoing. They were known to jump on a tram at the end of the day still dressed in their white splattered overalls; they wore black paint on their shoes. They mostly worked in pairs and could complete a project in a day or two, depending on the size and complexity.

During the late 1800s, sign painters mixed the paint by hand, using a complex and intricate balance of chemicals, color pigments and a white base, which contained high levels of lead. The shopkeeper may have asked the sign painter to help him design a message that would best portray the shop. Since many of the people were illiterate or did not speak the language, signs were particularly beneficial.

Sometimes the owner of the shop paid the wall painters directly for a specific sign advertising the wares to be purchased inside the shops. At other times, a national company might have purchased the space and advertised something like Coca-Cola. In essence, the shop owner was selling his wall as advertising space.

The price the wall dogs charged depended on the height of the building. The higher floors were considered more hazardous, even if the weather was good. Sometimes Mother Nature was not kind to the men as they swung from a rope attached to their waist at the top of the building, paint in one hand and a brush in the other. Some men used a hanging basket or trellis, but either way it was still very dangerous work. In effect, they had to be part gymnast and part artist.

The blueprint for a particular design often sprang from the sign painter himself. Using his expertise, he would produce a sketch and color choices best suited to the customer's needs. The letters were usually in block style taken directly from a sign painter's guidebook. The painter prepared a drawing, using a scale of one inch to one foot. He chose strong, contrasting colors for higher impact and always took into consideration the light and accessibility of viewing the advertisement. There was no point in painting a large, impressive design if it could not be viewed from a distance, such as

a block away. One such sign is still visible in Denver: the Brecht's Candies sign on Wazee Street, neatly tucked between buildings, can still be seen from several blocks away.

There was one potentially devastating effect from a long career as a wall dog: lead poisoning caused by exposure to white paint. It permeated their skin and their eyes, crippled their hands and weakened their bodies as it slowly poisoned them. Their brains were affected, they lost the ability to hear and then the deadly paint affected their nervous system. It was not until one hundred years later that lead was discovered to be the culprit, a fact not known to the men as they mixed a lethal dose of lead, linseed oil and color pigments. Later in life, the afflicted men appeared drunk or otherwise impaired, but in reality they suffered from "painter colic."

Over the years, as businesses changed hands, so did the signs. One sign was painted over another, but in the right light, both may be visible. These are often referred to as "ghost signs" because they seem to appear in certain lights and then disappear at other times. It is a strange phenomenon, and one can only imagine the level of lead paint that had to be used for the images to last more than 120 years.

In the early years, homesteaders not only had to worry about flooding, fires, the occasional Native American acts of aggression and the harsh winters and summers, but they also were concerned about the grasshoppers that would swarm at regular intervals. In 1865, a two-day wind storm brought grasshoppers in from the prairie that ate everything in their wake.

The *Denver Republican* reported on May 29, 1862:

> *One of the terrible plagues of Egypt now threatens Colorado. The grasshoppers are now making their appearance in innumerable numbers. Last year they were a source of great annoyance to our farmers, but this season there are grounds for serious apprehension....Several famers have turned their attention to other businesses. Some have stopped planting, hoeing, or cultivating, in hope of a favorable aspect in the future; while many not troubled with the plague, still work on in hopes, and plant such things as the insects won't eat.*

Five years later, in 1867, the grasshoppers were back again, but this time the farmers were ready. They devised some unusual and ingenious tactics to fight the plague. Some of their ideas worked and others did not. One method in particular seemed to work the best. Farmers used their horses to drag large branches along the ground, driving the insects into an irrigation

Pioneers described the devastation that could be caused by a grasshopper plague that would infest the fields, eat their crops and descend on their homes. One pioneer described the difficulties: "They ate everything in their path…all our hard work could be gone in a day's time." *Courtesy Pikes Peak Library District.*

canal. The canal contained kerosene dripping slowly from a barrel. Once the grasshoppers were in the canal, it was set alight.

Another approach appears to have been less effective, although it still involved fire. Farmers spread a soft coal tar substance onto a large sheet of metal and dragged it through the fields. The grasshoppers got stuck in the tar, which was later set on fire to destroy the insects.

During the grasshopper plague of 1899, a young woman wrote in her journal: "They came by the millions…about 5:00 or 6:00 and our family would take our tubs with sticks and start making a noise…they kind of turned and went around into the sagebrush…then, when it got dark, my father and brother would set light to the sagebrush."

Crime, Punishment and the Vigilance Committee

The crimes in Denver City during the early years were limited to thievery, drunkenness and the occasional shooting. Sometimes, things did get out of hand, as one traveler reported: "There are reports that vigilance committees, lynching, and desperados quick on the trigger, would shoot a friend for an impertinent remark."

This commentary may be true, or somewhat exaggerated, but what we do know is that several hangings or lynchings took place both quietly and publicly. Unfortunately, throughout American history, there have been thousands of cases of lynching. The origin of the term "lynch" is somewhat disputed. Some believe that it originated with Judge Charles Lynch of Virginia, yet others contend that it started in England and is an Anglo-Saxon word meaning to beat or punish. Either way, the term has been loosely used in America for centuries.

On April 8, 1858, John Stofel was hanged on a cottonwood tree at the corner of Eleventh and McGaa Streets. Evidently, he had some kind of fight with his brother-in-law, who later died. Stofel was quickly tried and found guilty as charged, and the penalty was quickly meted out.

Sam Dugan (also known as Sanford Dougan), a twenty-three-year-old petty criminal, and his friend Ed Franklin robbed Judge Orson Books, a well-known and respected man of Denver. City Marshal D.J. Cook was quickly on the robbers' trail, tracking them to their hotel. Dugan had taken off, leaving only Franklin in the room. When the marshal tried to reason with Franklin and take him to prison, a fight began. The marshal was forced to protect himself and fatally shot Franklin.

Determined to get both men, Marshal Cook began tracking Dugan. He captured him just south of the Wyoming border and brought him back to Denver for trial. Cook knew that it would be difficult to keep his prisoner safe while awaiting trial, so he decided to move him to a safer location. It was too late. En route, the Vigilance Committee seized control of Dugan,

Accused of killing a Denver judge, Sam Dugan escaped Denver but was caught at the Wyoming border by City Marshal D.J. Cook. While transferring his prisoner to a safe location, Cook lost control of his captive to the Vigilance Committee. After a quick trial, the committee judged Dugan guilty as charged and hanged him on a cottonwood tree at Market and Twelfth Streets. *Courtesy Denver Public Library.*

gave him a quick trial and hanged him on a cottonwood tree at Market and Twelfth Streets on November 20, 1868. The image on the opposite page shows Dugan wearing a jacket, pants and boots. The tree is bare of foliage due to the winter month. On the ground are handcuffs, a hat and a noose. A hatchet is lodged in the tree trunk. There is a note on the photograph that reads: "Sam Dugan hanged at Denver by vigi[lantes]. The frame and log buildings nearby advertise they are 'Bakery' and 'Meat' stores."

Enforcing law and order in a growing town was a difficult and often dangerous occupation. W.E. Sisty was the first marshal elected to office in 1859. Many others followed over the years until 1874, when a new position was created and J.C. McCallin became the first chief of police. Often during these early years, there were not enough metal insignia for the lawmen, and therefore they had to make do with makeshift fabric patches that were pinned directly to the lawmen's shirts.

Not only did the lawmen have to contend with drunken, gun-toting individuals, but they also had to cope with the Vigilance Committee, otherwise known as the Law and Order League. It was a well-organized group that took matters into its own hands. A judge presided, and the offender was tried by a group of his peers. Once given, the decision was final. The members not only sentenced many men to death but were also known to intimidate troublemakers by giving twenty-four or forty-eight hours to get out of town or "pay the consequences"; yet another threat was, "You have been warned." Most men heeded the advice and left town immediately or were escorted to the city limits.

Between 1859 and 1860, fourteen men were accused of murder and were brought before a jury of twelve men and at least one judge presiding. Six of the fourteen men were sentenced to death; the sentences were usually carried out the following day.

In 1861, Denver's first log jail was built in an alley between Market and Blake Streets and was destroyed by fire shortly after completion. Other, more durable jails were built of brick or stone. Twenty years later, on February 19, 1886, members of the police force were using horse-drawn patrol wagons to go about their daily business.

The last public hanging took place in July 1886. Andrew Green, an African American, was put into the "Engine of Death." The *Times-Republican* newspaper reported

> *that Green's body shot into the air, but it was not jerked up violently. It rose four feet, and the rebound was not noticeable. It was plain to see that the*

hanging was a botch, and a thrill and horror ran through the crowd. It was sickening when it was realized that the knot was not under the unfortunate man's ear, but high on the side of his head. A horrible death by strangling was inevitable. Many people turned away and others turned their heads.

During the first years of the twentieth century, small structures called "kiosks" or "drunk tanks" were placed at convenient locations around the city. They were basically holding pens that allowed policemen to lock up an individual until extra help and transportation were available. The 1905 photograph here was taken looking south toward Twenty-first and Larimer Streets. A policeman poses with a man who appears intoxicated, his hat perched jauntily to one side. The kiosk is small, with little room for anything other than standing. There are obviously no bathroom facilities. The policeman holds a billy club in his right hand. There are two men on the opposite side of the road, as well as one woman in a long dress. There is no traffic, although a dog appears partially behind a tree. A sign across the road reads, "Henry George—A Great Cigar 5 cents."

In March 1921, the Auto Bandit Chaser made its debut to help fight crime. It was a formidable piece of equipment built on a Cadillac

Drunkenness and disorderly conduct were constant worries to the policemen of Denver, so a "holding pen" or "kiosk" was designed and placed on a street corner in high-activity areas such as Larimer Street. Two men pose for the photograph, one seemingly inebriated, his hat pulled askew. The policeman holds a billy club. *Courtesy Denver Public Library.*

In March 1921, the Denver police force produced its latest crime-fighting vehicle. Built on a Cadillac chassis, it came equipped with bullet-proof, armor-plated sides; a windshield; powerful spotlights; a large bell; and a mounted machine gun on the front passenger side. Rumor has it that when the machine gun was fired the first time, it wobbled loose from its base. *Courtesy Denver Public Library.*

chassis and composed of bullet-proof, armor-plated sides; a bullet-proof windshield; powerful spotlights; a large bell; and a mounted machine gun on the front passenger side. The car was capable of holding six policemen specially trained in the art of riot control. Captain George Merritt aimed the machine gun, while the men seated behind him held trench guns and high-powered rifles with bayonets. Other men stand around the car in the image here. From left to right are Manager of Safety and Excise Frank M. Downer, Chief of Police Herbert R. Williams and Acting Deputy Chief Robert Carter. It is reported that when a policeman fired the machine gun during a demonstration, it rocked loose from its base and was ineffective.

Denver, like the majority of cities around the States, suffered from the usual drunkenness, robberies and occasional murders. Soon faced with prohibition, everything changed. Suddenly there was an opening for illicit liquor being ferried into Colorado, and the Smaldone family and friends quickly assumed that role.

Dick Kreck, in his wonderful book *Smaldone: The Untold Story of an American Crime Family*, described in great detail how the Smaldone family came to Denver, their struggles to be accepted, how they persevered, how they turned prohibition into a lucrative if illicit business and how they became the most notorious crime family in Colorado. Through careful and detailed interviews and by listening to audio tapes recorded by Clyde George Smaldone before his death, Kreck skillfully captured a personal and insightful glimpse into the Smaldone family. People in high places were "bought off," and members of the police force were in bed with the family and profited from the business—but not all.

Joann Irvine, longtime Denverite, recalled a night when she, her sister Sharon and their father had missed the last tram of the evening. Her father, Detective Joseph Dea, was holding his daughters' hands as they walked along the street when a car pulled alongside:

> *The driver leaned forward and recognized my father. They exchanged a few words, and then I heard the man say, "Do you want a ride?" My father accepted the offer, and Sharon and I got into the back seat; our father got in beside the driver. After being dropped off at our house, our father said, "You must never accept a ride from anyone or get into their car. Do you understand me?" It was some time before I knew the identity of that man; it was none other than Frank "Blackie" Mazza, an insider, and close friend of the Smaldone family.*

Serving the community ran in Joann Irvine's family. Not only was her father a detective, but also her grandfather, John F. Dea. Unfortunately, he lost his life to a crazed gunman on Saturday, February 11, 1933. The *Rocky Mountain News* reported the following day:

> *Policeman dying upon floor fatally wounds his assailant. Bystanders struck by flying bullets; Crowd attending auction thrown into panic and scrambles frantically for exits…pandemonium broke loose in the Colorado Auction Co. store, at 1456 Welton St., where the shooting occurred, as the nearly 100 men and women awaiting the auction dashed towards exits or sought shelter under furniture from the hail of bullets.*

Detectives Dea and Schneider had not expected any trouble. They were merely sent to the auction house to question the ownership of a bag of tools. The proprietor suspected that the tools were stolen property and so

contacted the police. When Mr. Gay Rice arrived with the tools at 2:00 p.m. that day, the police officers began to question him. Unbeknownst to the officers, Rice had been arrested twice previously for carrying a concealed weapon and was considered a "mental defective."

The *Rocky Mountain News* described how Rice continued to randomly shoot inside the auction room: "Reloading his automatic pistol time after time with extra clips he carried in a paper sack, the maniac sprayed the store and windows with nearly 50 bullets before his mad career was ended."

After pulling his gun, Rice killed Schneider, shot Dea twice and then ran through the auction gallery, firing randomly, shooting three men and killing one. He was able to fire fifty rounds before Dea rallied himself, despite his injuries, and fired four shots at Rice. The first three missed his target, but the fourth caught Rice in the forehead, and he died immediately. Dea was taken to the hospital but died four hours later. He was, however, able to describe what had happened at the auction house before he passed away. He said, "We hadn't even started to talk to him when he jerked out his gun. He shot me first and then he shot Schneider. Schneider didn't stand a chance."

Detective John F. Dea left behind his widow, Mary, and his three sons, Martin, Joseph and John.

The Ku Klux Klan

After World War I, patriotism and loyalty to the United States was very high, and this fueled the emergence of the Ku Klux Klan. It spread quietly and insidiously at first, but then, as it gained momentum, it spread like a pestilence throughout the country. The *Denver Post* reported on July 8, 1921, that the Klan had organized its party for the first time in Denver. Under the guise of patriotism and love for its fellow man, the Klan grew quickly, boasting a membership in the tens of thousands. The men of the party, known affectionately as kleagles, were sent into the community to convert members to their cause. They infiltrated businesses and schools and finally turned their attention to the political arena. They supported and helped bring to power those men who would use their influence to accomplish what the Klan could not do on its own.

Few people were spared the hate that spewed from Klan members. African Americans, Catholics, Mexicans, Jews and Italians all fell prey to intimidation, cross burnings, threats of castration and beatings. Mary Ulmer, a descendant of the Irish Catholic Gully family, recalled her great

uncle Paddy telling her that the KKK erected a cross on a family member's home and then set light to it. Intimidation such as this was rife in Denver during the early 1920s. Said Denver resident Nedra Werking:

> *You know, many, many people joined the KKK during the early 1920s and saw nothing wrong with it. Their members would visit shops and businesses in the area, and encourage them to join. After they had coerced a shop owner into joining the Klan, they provided a sign to put in the shop window. It read: KIGY and meant, "Klansmen I Greet You." My grandfather personally knew shopkeepers who joined and went out of business once that sign was displayed.*

In Sarah A. Gleason's book *I'd Do It Again*, she recalled a day when two Klan members called on Cyril Reynolds, a member of a school board in Douglas County, to complain about her newly appointed position. The men asked Reynolds why he had hired Sarah Gleason as a teacher, knowing that she was a Catholic. Some days later, when Sarah's father asked Mr. Reynolds how he had handled the difficult confrontation, he responded, "I politely told them to go to hell."

Despite the resistance to the KKK, the organization grew enormously in Denver. During the mid-1920s, it was estimated that its members totaled about 35,500. The total population of Colorado was close to 1 million, with more than 250,000 residents in Denver. The *Post* reported the Klan

Unlike many of their male counterparts, the women of the Ku Klux Klan appear proud to show their faces as they pose for this official photograph. They wear their traditional garb with the emblem of the KKK on the left-hand side of the robe, and hat. The woman in the center sports a dark cloak over her shoulders. *Courtesy Denver Public Library.*

as "the largest and the most efficiently organized political force in the state of Colorado today." Even politicians joined the cause. Mayor Benjamin Franklin Stapleton promised that "I will work with and for the Klan in the coming election, heart and soul." Once in office, Stapleton's support of the KKK began to wane, and soon the organization fell into disarray. When Dr. John Galen Locke, once grand dragon of the KKK of Colorado, died at the Brown Palace, few people were disappointed. In 1926, the political machine behind the KKK had all but disappeared from Denver.

Judge B. Lindsey wrote in 1925:

> *In parts of its ritual and pretences the organization seemed to have some high-sounding ideas. But back of those, as I soon learned, and since have been widely demonstrated, lay appeals of racial and religious fanaticism and hatred. Its success depended on stirring up such base passions as would inflame really patriotic communities and would corrupt law-abiding citizens who hereto had been tolerant and considerate to each other's rights and religion under the Constitution and laws of free America.*

Unlike the men of the KKK, the women were not so bashful and therefore freely posed for professional photographs to be taken. They wore white robes with the cross insignia placed close to their hearts. They also wore white, pointed hats with the insignia of the organization on the left-hand side. One woman appears to be wearing a dark-colored cape over her shoulders. According to many Denverites who have shared their private and personal stories, the KKK during the early 1920s was not considered a nefarious organization.

The following poem was written by A.J. Kiser, DDS, from Colorado Springs:

> *I'm not afraid of any klan.*
> *I claim the right to be a man.*
> *I claim the right to spread the truth,*
> *And help perchance the growing youth.*
> *The greatest thing on earth is mind,*
> *And truth is hard for some to find.*
> *Let's give the Negro and the Jew,*
> *As well as all the Catholics too,*
> *The right to live in our fair land,*
> *Despite the hooded Ku Klux band.*
> *Let's give all creeds the sacred right,*
> *To say their prayers and ask for light.*

Sports and Recreation

On Saturday morning, October 15, 1887, the headline of the *Denver Republic* boasted the "Immense Success of the Riding and Roping Tournament," but it was not the first tournament or rodeo held in the area. The Deer Trail Rodeo has the distinction of holding the earliest recorded rodeo ever. Rodeos brought together like-minded cowboys intent on showing their particular skills. Naturally, there was a keen rivalry between the young men from Camp Stool, Hashknife Ranch and the Mill Iron outfits as to who was the most competent cowboy. Under the hot afternoon sun on July 4, 1869, the winners took their prizes. All the bragging and boasting ceased, at least for another year.

The broncos for the tournament were brought in fresh off the range and therefore were fiery and mean. Each cowboy had to draw the name of his ride from a hat. Once the signal was given, he was let loose on his mount and had to ride his horse until it was compliant and at a standstill for it to be considered a win.

During the rodeo, an anonymous reporter summed up the scene perfectly. He made note that an Englishman, Emilnie Gardenshire, who worked as a cowhand for the Mill Iron outfit, did exceptionally well on a bronco called Montana Blizzard:

> *Gardenshire, rawhide whip in hand, crawled aboard cautiously and, once firm in his seat, began to larrup the bay unmercifully. The Englishman rode with hands free and kept plying his whip constantly. There was a frightful*

mix up of cowboy and horse, but Gardenshire refused to be unseated. For 15 minutes the bay bucked, pawed and jumped from side to side. Then, amid cheers, the mighty Blizzard succumbed, and Gardenshire rode him around the circle in a gentle loop.

More than twenty years later, the *Denver Republican* reported on Saturday, October 15, 1887, the success of the River Front Rodeo:

Eight thousand spectators crowded the grandstands and grounds. They were packed like sardines on the unroofed amphitheatre and massed twenty deep around the big corral. Nearly all of them could see. All of them could yell, and they all did.

It was both a novel and a great show. There wasn't much hippodrome about it. Every cowboy who entered the arena did his best, and the untamed broncos and long-horned steers did their best to get away. It was hard work for all of them and yet everybody enjoyed it. The cowboys were real, the bronchos [sic] *were real and the steers were to-the-manor born. The horses and the steers struck and kicked and squealed and bellowed, while gentlemen in silk hats pounded with their canes and ladies clapped their gloved hands together in excited delight, and the cowboy yell mingled with the cheers from everywhere.*

The scene of the show was a semi circular corral. It was equal in diameter to the length of the grand stand. The Judges were H.H. Metcalf, Carey Culver, J.H. Gorman and P.G. Webster. They occupied the stand which had been placed opposite the covered amphitheater. Inside the corral Billy McKinley of Cheyenne and W.W. Davis (Poney Bill) directed matters in the most approved fashion.

The crowd of itself was a sight worth going to see. Long before 9 o'clock, a line of people half a block long were extended from the ticket window up the street…so eager were they that they stood on everything. Every now and then a board would become too heavily loaded with men and boys who persisted in climbing on it and down it would come, the whole row with a crash. From of these falls Walter Conger sustained a broken arm and dislocated shoulder.

There were many notable spectators in the audience including a daughter of Senator Voohees and Thomas Nast. All watched in wonderment as the men rode out to perform. Bill Smith was the first man in the ring. He rode out on a clean-limbed pony and waved his hat in response to the greeting of admiring friends. Then the bunch of broncos that had never known a rope

were turned in. A sorrel was pointed out to Smith and after him he went… the battle was short and sharp…it was brute force.

Pinto Jim was the name of the next cowman. He was a rawboned colored man. A sorrel was pointed out to him. He made several failures in getting the rope in the right place and then had a battle that was fierce. At last, when the horse was well nigh worn out with the constant plunging, Jim caught a jacquima on him, had a saddle in place and was on his back in a minute more.

None knew who the next man was who rode out on a white pony. They called him Dull Knife and he was from Meeker. That was all the information obtainable. But Dull Knife was a daisy. With new white sombrero, Mexican saddle, leather-fringed chaparejos, flaming red kerchief, belt and ivory-handled revolver and knife, he was all that the Eastern imagination of the typical cowboy could picture. As a bronco-breaker, however, he wasn't a brilliant success. A bay was pointed out to him and away he went. It didn't take that cunning bay bronco more than a minute to find out that he was wanted. With all the natural cussedness of his breed…with flashing eyes and streaming mane and tail, the animal was a pretty picture. Dull Knife made a skillful move caught the horse by twining the rope around his legs…

The concluding exhibit of the show was the roping and stretching a steer for branding. A peculiarly fractious animal was caught by William Smith and William Cook and stretched helpless in 1 minute and 10 seconds. The program to-day will be the same as that of yesterday with an additional exhibition of fancy riding which will include the feat of picking up twenty potatoes from horseback. The corral will be moved thirty feet from the grand stand so that more people will be enabled to see all that takes place with the inclosure [sic].

The actual count of those present yesterday is as follows: Tickets sold, 7,700; free admissions, 800; exhibitors and employees 300; total, 8,800.

Forty years after the very successful River Front Rodeo, Chicago gangster Leland Varain—aka "Louis Alterie" (perhaps his favorite alias), "Diamond Jack" and "Two Gun Louis"—requested permission from C.D. Vail, manager of Improvements and Parks to hold a rodeo at Overland Park on August 6, 7 and 8, 1925. Varain told the manger that he was "pulling together a crack outfit" using his Jarre Canyon ranch as a base to get it organized. Vail told Varain that he would get together at a later date with his decision on the rental of the park.

According to Randy Varain, great-nephew of Leland Varain—who incidentally took a completely different path to that of his notorious relative by serving twenty years in law enforcement and a further twenty years as a judge—commented:

> *I've heard from family members that Leland was a good horseman. Growing up on a ranch in Merced Falls, California, he learned to ride at an early age. He was a tall man, around six feet, with dark hair. He was also a strong man and quite muscular. He used to carry two firearms for protection—two .45s in fact, one under each arm…and yes, I can confirm that he liked diamonds. There was nothing he liked to do more than spending time on his ranch. He loved the outdoor life, horses and Colorado. When things got really hot for him in Chicago, he went to Colorado first and from there on to Merced Falls, where the family still owned a ranch. He was part of a very large family and was always welcome there.*

For many years, Leland Varain had been a hit man for the North Side Gang in Chicago. When the leader of the gang, Dean O'Banion, was

Chicago gangster and crime boss Dean O'Banion, leader of the North Side Gang in Chicago (front row, third left), poses with Leland Varain, front row, sixth left) at Jarre Canyon Ranch. O'Banion and Varain were killed by rival gangs on the streets of Chicago. This later led to the Valentine's Day Massacre. *Courtesy Castle Rock Museum.*

shot to death by rival gang members in his florist shop on November 24, 1924, Varain wanted immediate payback. He was incensed and demanded retribution. The new boss of the North Street Gang, Hymie Weiss, took control of the situation and told Varain to leave town for a while. The next time we hear of Varain, he is living at his ranch at Jarre Canyon, close to Sedalia, just south of Denver.

When Varain fled Illinois, he was wanted in connection with the theft of $50,000 worth of diamonds. When word spread that he was living at his ranch in Sedalia, and was in Castle Rock on business, Sheriff McKissack of Castle Rock went to investigate. The sheriff approached Varain, who brazenly denied being the gang member. McKissack appeared to be satisfied with the answer and went on his way. The following week, when the charges in Chicago were dropped, Varain gave an interview to the *Denver Post*, and a photograph was taken. When the sheriff saw the newspaper article and photograph, he knew that he had been duped. The *Post* reported the incident using one of Varain's aliases, Alterie:

> *Alterie, a hijacker, union strong-arm, and killer, was well known in Denver. He owned a ranch in Jarre Canyon near Sedalia, and was often seen strutting around the city when he was in Colorado. He posed a striking figure in his huge white Stetson, diamond-littered cufflinks and belt buckle, and expensive, custom made cowboy boots. His cream colored automobile had a gigantic set of bullhorns attached to the hood. He was fond of saying that although his livelihood was in Chicago, his heart belonged to the West; he was more at home on a bucking bronco than in a touring car, and preferred wrestling unruly steers to fellow gangsters.*

Permission was granted for the rodeo to be held on August 7, 8 and 9, 1925. The *Denver Post* announced that "Diamond Jack's" Rocky Mountain Roundup was all set and rearing to go. The paper even published the official program, beginning Friday morning with "Diamond Jack" Alterie and his prized stallion, King George. No expense was spared. Days earlier, on Thursday, July 30, the *Denver Post* had announced:

WILD STEERS ON WAY FOR RODEO AT STOCKYARDS

> *They're stamped in the steer herds into Denver—steers that never felt the tug of a surcingle—wild bellerin' long-horned kind—and there's a herd of 135 of 'em headin' for the stockyards, where, on August 7, 8 and*

9 Denver's own Rocky Mountain roundup directed by "Diamond Jack" Alterie, hold forth.

The big roundup will use 200 head of wild stock. One hundred will be steers for riding and bulldogging and the other 100—Ah! The buckinest brons that ever tried to shake a saddle off!

The big stockyards stadium, dormant the year around except during the anual [sic] Horse Show Week, will be filled with its first summer crowd.

Chutes for the saddling of wild horses are being built. Concession men are all ready to add their cries to the din of the roundup. The public's itchin', the broncs rarin' and th' band's tunin' up for Denver's first real hot time in many a moon.

One of the big novelties will be the First Logan military polo mules. Their act is the most ludicrous spectacle obtainable, and Red Sublett, internationally known cowboy clown, is arranging a special jest stunt to be used in connection with the mule act.

World champions began turning up to defend their titles. Female participants also came from every state. Ione Snodgrass from Durant, Oklahoma ("who can bust a bronc better better'n a lot of men 'punchers'"); Irene Fuller; Bonnie Foster; and Rose Smith had been favorites for many years. They toured from state to state competing for the purse money. In 1923, Rose Smith won almost $1,000 at Madison Square Garden for her trick and bronc riding and also for the costume event. The *Denver Post* declared:

Claire Belacher of Durant, Oklahoma has arrived with a carload of show horses. She will also participate in the bucking events…Mae Louis Martin of Fort Morgan is the only child trick rider and actual contestant in roundup events, is here for the show. This little girl is the marvel of the day and is expected to be one of the outstanding sensations of the show.

Precisely at noon on Friday, August 7, 1925, large crowds eagerly gathered and awaited the procession of Leland Varain and the other performers, who marched through the streets. The *Denver Post* reported that a party was held in front of its offices:

Bombs, airplanes scattering parachutes containing tickets to the big Rocky Mountain Roundup to be held at the Stockyards stadium Friday, Saturday, and Sunday, music by Ernie Moore's jazzerinos, dancing by "Red" Sublett

and his trick mule, Calamity, and a demonstration of rope artistry by "Frog" Newton entertained a big crowd of Denverites in front of the Denver Post at noon Friday, as the preliminary to the opening of the rodeo later in the day. "Diamond Jack" Alterie, promoter with King George, his beautiful horse promptly on the tick of noon, the crowd started gathering. A minute later, the airplanes hovered over the business district, and the parachutes, each containing free tickets to the roundup, were turned loose from the planes.

By all accounts, the rodeo was a great success, and Leland Varain was hailed as "King of Roundup Producers." On Monday, August 10, 1925, the *Denver Post* concluded the coverage:

When "Diamond Jack" Alterie leaped from the saddle of his pony and landed on the horns of a Brahma steer and bulldogged the critter in forty-nine seconds at the stockyards stadium Sunday night, he capped the climax of the thrilling three-day Rocky Mountain roundup. It was "Diamond Jack's" only bulldogging exhibition during the whole show, and he displayed great class. Cowboys participating in the show hailed Jack as the king of rodeo producers…they declared Alterie is the only show owner in the business who rides bucking horses with the hired help. They are all coming back again 100 per cent, they declared.

Leland Varain, flush with excitement and success, promised Denverites that he would be back the following year as the hype continued for days. The winners and their purses were listed in the *Denver Post*:

"Dutch" Foster of Littleton out-rode the world champion, Billie Wilkinson in the bronc riding finals Sunday night and won the Denver championship, Wilkinson taking second. Besides the $500 purse, Foster won the Denver Post trophy, Al Garret won third place…King Merritt of Horse Creek, Wyoming, carried away the $500 purse for bulldogging…Marie Gibson copped the purse in the ladies' bronco riding; Prairie Lily Allen second, and Brida Miller third.

The following year, as promised, Leland Varain made plans for another rodeo, but in Chicago, the feuding between the North Side Gang and the Chicago Outfit was reaching boiling point as each tried to gain supremacy.

Meanwhile, in Denver, Varain proved to be a real showman. He was adept at bringing people together and promised that this rodeo would be

He was always a kindhearted man to his family. Those men in the ring may have seen him differently, but to us, he was simply "Uncle Sonny." We were devastated when he was defeated by Cassius Clay. We cried and cried. He was our extended family after all. Still, he had his successes, and he enjoyed life. He lived in a small house on Monaco…and used to train at his home. When he moved out; the new owners had to do some repairs because Sonny's punch ball had left dents in the walls.

Being the niece of Sonny, I was often teased by my classmates. They would say, "Don't mess with her…she's Sonny Liston's niece."

Sonny had had a hard life. We all knew that. He'd been in trouble on occasions, but that didn't make any difference to us…we loved him regardless. His problems didn't stop him from becoming the world heavyweight champion—sometimes, it's still hard for us to believe it happened at all.

Liston had his share of controversies. His first fight against Cassius Clay was shrouded in mystery, as Cassius complained that something on Liston's gloves had caused him to tear up, making it hard to see his opponent. The trainer quickly sponged Clay's eyes, and he went on to win the fight in the seventh round on a technical knockout. Boos and hisses followed as Cassius Clay danced around the ring chanting, "I am the greatest. I am the greatest."

We can only imagine how pleased Liston was in 1964 when, Cassius Clay, now Muhammad Ali, fought English heavyweight Henry Cooper, known affectionately by the Brits as "Our 'Enry." Cooper landed his trademark "Enry's 'Ammer" on Ali, but Ali was saved by the ropes. When Ali was interviewed later, he said that Cooper had hit him so hard, "he felt sure his ancestors in Africa must have felt it."

Many fighters of the day feared even getting into the ring with Liston. Henry Cooper's manager, Jim Wicks said, "We don't even want to meet Liston walking down the same street."

Sonny Liston was a complex and interesting man with a varied and somewhat controversial background. His death on December 30, 1970, was no less intriguing than his life.

Father Edward P. Murphy from Denver said of Sonny Liston: "He's actually a big, soft boy what has been kicked around ever since he was born…he wants to be liked. And he wants to do something for his people so they will be proud of him."

Joe Louis said of Sonny: "Sonny could do more for boxing than any champion in the history of the fight game; he can set an example to kids everywhere that anyone can pull up and make something of themselves."

Cynthia Liston Bronson commented:

> *When I look back, I think Sonny would have been proud of me, too, because when I became the postmaster of the Larkspur Post Office, a reporter from the Denver Weekly News wrote a feature piece about my new position, and that I was the first African American woman postmaster in Colorado. However, since then, I've discovered that in 1904, a woman called Cleo Swanson was the first African American woman postmaster in Colorado—but think of it…that was more than one hundred years ago. Now I have my own Contract Postal Unit in Aurora. It is hard work, but I enjoy a challenge. Our family has come a long way since the '60s; much has been achieved.*

First African American Intercollegiate Team

Frederick Roberts and a man by the name of Jackson were the first two African American intercollegiate students in Colorado. They pose in the image below with their team, the Tigers, in 1904. Roberts is kneeling at

In 1904, Jackson and Roberts, two African American intercollegiate football players, arrived in Boulder for a game but were refused a room in town. Unperturbed, the coach collected all his players and left for Denver, where the whole team found accommodation. *Courtesy Special Collections, Colorado College.*

left, and Jackson is standing far right. In 1905, the team traveled to Boulder, Colorado, intent on staying at the Boulderado Hotel. Once there, the coach was told that there was room for the majority of the team, but not for his two African American players. Considering that an insult, Coach John Richards collected his men and left for Denver, where a hotel was willing and able to accommodate his whole team.

Not much is known about Jackson, although it is believed that he grew up in Denver and attended Colorado College from 1903 to 1907.

After graduating from college, Roberts started an African American newspaper called the *Light* and then went on to become the vice-president of the Freemen Mining and Development Company. Originally from Los Angeles, he returned to California in 1918 and became the first African American elected to the California state legislature.

ELITCH GARDENS

The rapid growth of the city attracted people from all walks of life. An abundance of men seeking their fortunes brought with them their need for booze, gambling and women. Saloons and brothels sprang up, and beautiful working women walked the streets in their fine clothes and rode around town in elegant carriages.

We can only imagine what Mary and John Elitch must have felt on that afternoon when the young couple stepped onto the platform at the Denver railroad station. Like many others, they believed that the fledgling city had much to offer and so left their home in San Francisco in the hopes of starting a new business. John had a fondness for the theater and had even performed as an actor on occasions.

Immediately, John went to work and got himself a job at the Arcade Restaurant on Larimer Street, and within the year, he had purchased a building at 1541 Arapahoe Street. He called his new establishment the Elitch Palace Dining Room. Soon thereafter, the couple rubbed shoulders with influential men such as Mayor Wolff Londoner, Senator Tabor and Governors John Evans and John Routt, all of whom would frequent the dining room.

Although Mary enjoyed the quietness of her little cottage, John had other ideas for his young bride. In 1888, he bought the Chilcott Farm from Martha Hagar. Previously, Hagar had lived in Empire with her husband and sons. They traded with the Ute Indians who lived in the area, and all was

peaceful until one fateful day when a band of renegade Indians attacked and killed her husband. Martha Hagar moved to Denver, where she met and married William Chilcott. Together they homesteaded the sixteen-acre farm in the Highlands northwest of Denver, where Martha planted numerous cottonwood and apple trees. Later, that property became Elitch Gardens.

John and Mary felt that they may have overextended themselves financially with their new venture. John's fears were put to rest when Mary fell in love with the farm upon seeing it for the first time. She later said, "The Highlands were something of a wilderness, for few streets were in common use. Mr. Elitch and I would take the buggy from the gates of our ranch diagonally across the plains and down the hill, across the Platte River into Denver. A visit to 'the City' was a day's event to us."

In 1880, the population of Denver had reached a staggering 35,629 people. John, being an entrepreneur at heart, decided on a new venture. He and Mary decided to design, build and manage an amusement park, a place where families could enjoy an afternoon of entertainment away from the saloons and pool joints of Denver. He would use his newfound celebrity with well-known and influential men of the city to support his latest endeavor.

The gates to the park swung open on May 1, 1890, under a gloomy sky, but nothing could dampen the spirits of those in attendance as trumpeters heralded the opening. John's friend P.T. Barnum attended the opening and brought with him Mr. and Mrs. Tom Thumb.

Although John and Mary did not have children

A portrait of Mary Elitch Long hangs in the Denver Woman's Press Club. In 1898, Mary became an honorary member of the club. Mary and her husband, John, started Elitch Gardens on May 1, 1890.

of their own, she seemed to find enormous pleasure in caring for the animals at the park. However, she was annoyed one day when she rushed off in an emergency:

> *I was called away suddenly to the bedside of a sick friend and neglected to close the house. When I returned, I saw a sight I'll never forget. Three deer, an elk and an ostrich were in my home. The ostrich was in the kitchen knocking pans and dishes all over the room. The elk was in the pantry. She had found a large jar of jam and smeared it all over the wall, floor, shelves and herself. One deer lay on my bed and the other two were roaming about the parlor. They had upset some vases of flowers and water was spilled all over.*

By the time the gates were closed on Labor Day, John and Mary had grossed $35,000, but the happiness was short-lived. John died a few months later, leaving Mary alone to manage the gardens. Heartbroken, she decided to keep the facility open in memory of her husband. It thrived under her care and administration. In 1909, her lifetime friend, Maggie "Unsinkable Molly" Brown, performed a yodeling demonstration to aid in the Garden's Kindness to Animals benefit. Mary reminisced in later years: "My husband's death left our Gardens in my inexperienced hands. Our great adventure was still something of an experiment. I decided to undertake the management of the place myself, and so for the next twenty-six years, I operated the resort alone. It was a heavy burden."

Sells-Floto Circus

Just ten years after John and Mary started Elitch Gardens, Harry Tammen and Frederick G. Bonfils started a circus that would eventually challenge "The Greatest Show on Earth." Neither man could possibly have imaged the success that the circus would bring them. Every year they made money and then pumped it back into the business, making the following year even more successful.

The Otto Floto Dog and Pony Show was started innocently enough—by Tammen and Bonfils breaking with tradition. Usually, a circus troupe began on a small scale, with a few wagons. Instead, the new owners started their business with an impressive eight railroad cars, calling their new endeavor Otto Floto, the name of a sports editor of the *Denver Post*. Six years later, the

show traveled to the East Coast, challenging the most successful circus of all time, the Ringling Bros. and Barnum and Bailey.

In 1906, William Sells became the manager of the circus. He took stock in the business and allowed his name to be used in the name Sells-Floto Circus. It was a significant name in the industry, and therefore Tammen took full advantage. Posters and billboards advertised that the circus was on its way and enticed the public to wait for the special event. The entourage had grown to more than thirty railroad cars and must have proved an impressive sight as it traveled from town to town.

As the circus grew, so did the animals and staff to care for them, but it was not only animals that stole the show. Tammen knew that he had to be creative to keep ahead of his rivals. He arranged for celebrities of the day to perform. Buffalo Bill and world heavyweight boxing champions Jack Dempsey and Jess Willard made appearances, to the delight of the crowds. Tammen also had a fondness for elephants and included at least ten in the show. He also tried to breed a baby elephant from a male and female in his troupe. Three times the experiment was tried, but all were unsuccessful, and the babies died. The third baby elephant was a bull calf. Tammen was ecstatic. Tambon (given the name for the owners) lived for almost a month, and when he died, Tammen was devastated.

Members of Bayley's Circus pose for this unusual photograph. The men appear to be dressed in feminine attire, a man holds a sign advertising he is a "philosopher," a young girl on the right holds a tennis racquet and a woman (center back) holds a camera—was the donkey posed? *Courtesy Special Collections, Colorado College.*

A true showman at heart, Tammen decided to get a new addition for his show. He contacted Carl Hagenbeck, a well-known animal dealer, and arranged to purchase a new elephant. Her name was Old Mamma. She was an intelligent and well-trained elephant who performed well, was obedient and would be a welcome addition to show.

Everyone was anxious about the new elephant, but she would not perform on command and steadfastly ignored her trainers. Upset and disillusioned, Tammen complained to Hagenbeck, who in turn let loose in German, his native language. This gave Tammen an idea. He found a trainer who could speak German and instructed him to give Old Mamma her commands in that language. To everyone's delight, she did exactly as she was instructed. Eventually, Old Mamma became the "mother" and leader of the whole herd.

Other, smaller circuses came to town, too, but they paled in comparison to the Sells-Floto Show and the Ringling Bros.' circuses, and simply could not compete. They did perhaps try to set themselves apart from their enormous competition by offering different acts. Bayley's Circus appears to be a ragtag group of men dressed in feminine robes and hats. More women than men pose for the photograph, along with the donkey.

Religion and Charitable Organizations

Salvation Army

On January 7, 1884, a particularly bitterly cold day in Denver, two women walked the streets of town distributing leaflets and circulars championing the cause of the Salvation Army. One of the women, Mrs. Gould, a Denverite, was well known for her temperance and religious work in the Platte Bottoms, but she was not a member of the Salvation Army because no citadel or meetinghouse had been formally recognized by the Salvation Army. It is thought that the women had heard, read or attended a Salvation Army meeting in the East and perhaps decided to bring General William Booth's basic tenets to the growing city. The two women had even adopted the attire of the female members of the Army and wore the customary long, black dresses and bonnets trimmed in red silk, with the name "Salvation Army" emblazoned in gold lettering on the ribbons.

According to Major Edward Ringle of the Salvation Army, "The reporters were often ill informed and completely wrong at times. The two women who walked the streets were not the forerunners of the army and new to town, but indeed were local women." A *Rocky Mountain News* article on January 7, 1884, noted:

> It is not known when the main army will reach Denver, but it will be within a very short time. Then the unbelievers will receive a benefit such

as was never before accorded them, for the Salvationists have attained a reputation in the East of being very thorough, as well as demonstrative, in their work of endeavoring to bring about reforms and saving souls from a frightful hereafter. The good they will accomplish in Denver remains to be seen. Not that Denver really needs any reformation.

Unfortunately, the early history of the Salvation Army in Denver from 1884 is sparse. Later, excellent records were kept listing the Corps' headquarters, the members' names and, later still, their ranks and photographs.

During the late 1800s, the Baldwin family arrived in Denver. Fourth-generation Denver resident Lieutenant Colonel Peacock remembered stories from his great-grandmother, Emily Baldwin, and grandma, Florence (Baldwin) Bartlett, when they came to town:

My family came to Colorado as part of William Booth's overseas farm colony in 1897. My grandparents, and my twelve-year-old grandmother, together with her younger siblings came from Nottingham England to

The Denver Corps of the Salvation Army in 1888, taken at the "McNasser Ave., down under 23rd St. Viaduct." On December 9 and 10, 1894, General William Booth, founding member of the Salvation Army, set foot in Denver. After weeks of gruelling travel—his first trip across the Great Divide—he experienced such a reception that it was hard for him to describe. *Courtesy Salvation Army, Denver Citadel.*

Canada. They journeyed from Canada to Chicago and then across to Fort Amity, near Holly, Colorado. Their journey to Fort Amity was via train.

I regret never meeting my great-grandfather, who died before I was born. My grandmother lived to be eighty-six years and my great-grandmother until she was ninety-seven years of age. Great Grandma died around 1953 when I was eight or nine years old. Grandma Florence (Baldwin) Bartlett and Great-Grandma Emily Baldwin came frequently to our house for meals or BBQs. At these times, I remember both grandmothers telling me stories of how they came from Canada, through Chicago, and across the plains to Colorado. They would always try to impress this young boy by saying, "And, as we looked out the window, we saw Indians everywhere." Of course, at that time, I didn't catch the significance, and simply answered, "Yes, grandmas, I see the Indians every night at 6:00 p.m. on my television." When I think back, they must have smiled at my naïveté because they were talking about native Indians, while I was referring to the silver screen. The Fort Amity Farm Colony closed in 1906, and everyone came to Denver, where my mother, aunts and uncles were all born. Many years later, I was born in Denver, as were my brothers and sisters. As an adult, I made a trip to the Salvation Army Archives in London and discovered that my great-grandfather was the construction foreman for the colony at Fort Amity, and my great grandmother had been the nurse. During its peak, Fort Amity had 400 families and approximately 1,600 people. Unfortunately, it had to close because the soil had become saline, and in those days they did not know how to counteract that.

On December 9 and 10, 1894, General William Booth, founding member of the Salvation Army and who began his ministry in the slums of London, set foot in Denver. After weeks of gruelling travel, and his first trip across the Continental Divide, he experienced such a reception that it was hard for him to describe. Despite the beauty of the mountains, the *Rocky Mountain News* reported that General Booth was here not for a "pleasure trip, saving souls is his business." The report continued:

> Altogether, a remarkable lot of people are these Salvationists. They were seen at their very best yesterday for the visit of their general had stirred all the religious enthusiasm of their natures. Poke bonnets sometime enhance loveliness. Plain garb sometimes sets off beauty. Military coats often add materially to manly looks. So it came about that this Salvation Army of Colorado, as massed yesterday, proved a fine looking body.

Then the unknown author asks a question:

> READER—*What have you done since this church opened to make it a benefit to mankind? We Trust your entire duty to this mission. This church extended a helping hand to the poor people outside of this church. Do you allow the poor to enter this church with the same welcome as those in costly robes?*

The magnificent Trinity Church holds some intriguing mysteries. Why did the stained-glass artisan use a different color in a tiny piece of the "rose" designs? Who wrote the messages in the rafters that can only be viewed by climbing into the attic? *Courtesy Trinity United Methodist Church.*

Located on the north and south walls inside the sanctuary are two viewing boxes. They are ideally situated for viewing the services and worshipers and listening to the choir and organ. These were originally called "invalid boxes" and were used to accommodate pregnant parishioners. Comfortable padded chairs were provided, and a lightweight curtain would have been used to shield the ladies from the congregation. However, to gain access to the box meant climbing a long flight of steps, and one wonders how often the boxes were used for this purpose. Nowadays, the boxes are simply called "Bishops' Boxes."

There are two "rose" stained-glass windows on the north and south walls. The magnificent windows represent the twelve apostles and the twelve tribes of Israel, respectively. Each section is carefully matched to the next both in clarity and color, with the exception of one tiny piece of glass. Remarked Shaun Boyd, archivist at the Castle Rock Historical Research Center, Douglas County Libraries: "Nobody knows why the artisan deliberately used a different color for this tiny piece. There has been much speculation over the years. Did he run out of blue glass and use a piece of red instead? Conversely, some people believe it was a deliberate mistake because only God is perfect."

Mary Sinton of Sinton Dairy, Colorado Springs, recorded in her journal that she visited Trinity United Methodist Church in 1892, when she and her husband were looking to expand their business. Her journal describes the beauty, the acoustics and the friendliness of the congregation. The most significant change in the sanctuary since Stinton's time was the completion of the center aisle in the late 1920s. Lynn Willcockson described how the church continues to play a significant role in the life of its more than 1,800 members and of the entire Denver community:

> *The church was organized in August of 1859 as Denver's First Church. Trinity has adopted a slogan: "We're Here For Good." This is evident in that now over three thousand people come through the doors of Trinity each week. This includes the lunch program for the homeless three days a week, those who attend the Monday through Friday support groups (e.g., AA and CA), music classes, plus community organizations that use the Trinity facilities for their meetings. Mission outreach both within the United States and in foreign countries is a significant part of the ministry. In addition, there are two Sunday worship services and educational classes for children through adults. With members coming from the six-county Metro areas, Trinity offers a traditional worship experience for today's contemporary people.*

A Matter of Survival

Most Coloradans know how quickly the weather can change, especially during the winter months—sunny and pleasant one minute, cruel and punishing the next.

On November 8, 1873, a twenty-one-man party left Bingham Canyon, Utah, for Denver, attracted by the lure of gold. Each looking to make his fortune, they hired Alfred Packer as their guide after he boasted, "The Colorados, I know 'em like the back of my hand." Almost from the outset the party was in trouble, losing a majority of its food in a river crossing, and then a snowstorm hit. Still, the men survived and made their way to Chief Ouray's camp near Montrose, Colorado.

Ouray was true to his title as "the White Man's Friend." He supplied food and shelter to the men and advised them to wait until spring before setting out for the gold mines.

All but six men took Ouray's advice. Alfred Packer, Israel Swan, George Noon, Frank Miller, James Humphreys and Wilson Bell, unable to control their desire for gold, left the relative safety of Ouray's camp on February 9, 1874. Only one man, Packer, would live to tell the tale.

Alfred Packer was born in Allegheny County, Pennsylvania, on January 21, 1842. He was, by all accounts, a rough individual, with an unusually high-pitched, whining voice that grated on those people around him. He joined the Union army in April 1862 but was discharged within the year due to a physical disability.

Chief Ouray was an exceptional man who tried to keep the peace between his own people and the settlers. He spoke several languages and was a gifted negotiator and therefore represented various tribes when he attended peace treaty negotiations in Washington. Hayes said of Ouray that he was "the most intellectual man [he had] ever conversed with." *Courtesy Pikes Peak Library District.*

Two months after leaving Chief Ouray's camp, a disheveled Packer—his filthy black hair matted to his head, his beard long and unruly and strips of blankets tied around his feet—staggered into the Los Pinos Indian Agency on April 16, 1874. Herman Lauter, government clerk and constable; Stephen A. Dole, secretary to the Indian agent; and Major James P. Downer watched in amazement as Packer stumbled toward them.

Over the next few days, Packer told too many different versions of what had happened in the mountains, and General Adams of the agency became very suspicious. Unable to determine the truth, Adams decided to incarcerate Packer until he could go to trial. Unfortunately, the jail was not secure, and with the help of a friend, Packer escaped and was on the run for eight years until the law caught up with him.

On March 11, 1883, by sheer luck, Jean "Frenchy" Cabazon, a peddler by trade and member of the original twenty-one-man group that had left Utah eight years earlier, walked into a roadhouse in Wyoming to sell his wares. Despite the noise, his ears pricked up with interest when he heard a familiar voice and recognized it as belonging to the notorious Alfred Packer. The local sheriff was called, and he approached the man they all knew as John Swartze. Packer admitted his real identity and was arrested without incident. Sheriff Clair Smith of Hinsdale Country, Colorado, escorted Packer to Denver, arriving on March 16.

The newspapers ran the story, calling Packer "the ghoul of the San Juan's." That night, in the presence of Sheriffs Campbell and Smith, U.S. Marshal Simon W. Cantril and General Adams, Packer penned what

became known as his "second confession": "I Alfred Packer, desire to make a true and voluntary statement in regard to the occurrences in the winter of 1873–1874. I wish to make it to General Adams because I have made one once before about the same matter."

In his confession, Packer describes clearly how he returned from the top of the mountain after scouting the area. Upon his return, he found that Wilson Bell had killed all four of his companions and that he was, in fact, devouring a piece of meat he had cut from the leg of Frank Miller:

> *I came within a rod of the fire. When the man saw me, he got up with his hatchet towards me when I shot him sideways through the belly. He fell on his face, the hatchet fell forward. I grabbed it and hit him in the top of the head. I camped that night at the fire, sat up all night. The next morning I followed my tracks up the mountain but I could not make it, the snow was too deep and I came back…I tried to get away every day but could not so I lived off the flesh of these men, the bigger part of 60 days. At the last camp just before I reached the agency, I ate the last pieces of human meat. This meat I cooked at the camp before I started out and put it into a bag and carried the bag with me. I could not eat but a little at a time.*

Alfred Packer, self-proclaimed cannibal, survived for almost two months on his five companions' remains before staggering into the Los Pinos Indian Agency on April 16, 1874. He claimed only to have killed one man in self-defense. A chance incident brought him back to Denver, where he stood trial. *Courtesy Lake City Museum.*

Six men left Chief Ouray's camp in Montrose after he had counseled them to wait until spring before resuming their journey to Denver. Only one person survived: Alfred Packer. The other five members of the expedition died and are remembered on a memorial close to where their remains were found. Those men were Israel Swan, George Noon, Frank Miller, James Humphreys and Wilson Bell. *Courtesy Donald Wallace.*

Packer was put on trial, but the jury only convicted him of manslaughter in the death of Wilson Bell. Packer was incarcerated at Canon City Colorado from 1886 to 1901.

In 1901, after being released from prison, Packer was offered a position with the Sells-Floto Circus as a freak show exhibit. Instead he took a position as a guard at the *Denver Post*. He died of a stroke at the age of sixty-five years. He is buried at Littleton Cemetery, Colorado.

Mary Ulmer, descendant of the Gully family, remembers stories told by her Uncle Paddy O'Brien, who knew Alfred Packer personally because they lived in the same town. She said that her uncle never believed that Packer was capable of doing such awful things and that he was a "fraud." Ulmer confirmed that her uncle mentioned that Packer had a "whining, nasal voice that grated on his nerves."

BLUE BROTHERS' JOURNEY

We can only imagine the hardships that the first pioneers encountered during their journey west, but the lure of gold was strong and brought them by the

thousands. Families sold everything in their possession to buy a Conestoga wagon and load it with essentials and purchase a team of mules for the journey west. The Blue brothers were one such family. Alexander, Daniel and Charles (the youngest) left Leavenworth, Kansas, and undertook a six-hundred-mile journey to Denver that ended in disaster.

A few months before they left, a man named Bacon mapped out the route as he made his way to California for the gold rush. It was a route well known by the native Cherokee Indians for its harsh winters and lack of food and water. The trail was nicknamed the "Unmarked Grave Route."

Along the way, the brothers picked up a traveling companion by the name of Soleg. All were in good spirits, unaware of the harsh road that lay ahead. None could have imagined the outcome of their fateful journey. Soon their food was gone, but believing that they were not too far from civilization, they decided to kill their horse. They feasted for days on the horse meat and loaded the remains in the cart. Each man took a turn in the harness, but this sapped their strength and increased the need for sustenance.

A few days later, Soleg became very weak and knew he was about to die. He made the brothers promise to consume his body so that they would survive. They took just over a week to devour his body.

Alexander was the next to perish, and before he died, he begged his brothers to use his body for food. They did. The last two brothers traveled for days and days until Charles, the youngest brother, died begging his brother to save himself by using his body for food.

In August 1859, *Harper's Weekly* reported:

> [O]*f one party some twelve or fifteen died in a state of starvation, and in some instances the survivors preserved their own lives by eating the dead bodies of their former companions…*[one lone survivor had] *eaten the dead bodies of his brethren, and was found by the Indians in a dying state, and by them carried to the nearest passing train.*

When Daniel Blue was found, he was at death's door. Barely able to walk, his mind was so disturbed by his acts of cannibalism that he never fully recovered. The people of Denver felt so sorry for the young man that they collected enough money to send him back to his family.

Water Everywhere

The Flooding of Cherry Creek

Many people making the perilous journey to Denver died on the plains because they did not have enough food, but more died because they ran out of water. Trails were given the ominous titles of "Starvation Trail" and "Unmarked Grave Route."

Upon arrival in Denver, the South Platte and Cherry Creek Rivers must have been a welcome sight to the pioneers. First they built makeshift surface wells or carried their water in buckets and bottles; in 1867, the city ditch was built to connect the South Platte River in Littleton to Capitol Hill. It was a successful project, and Denver's water supply system became famous, in part because Mr. C.P. Allen's pipe design using wooden staves was considered one of the best in the country. The pipes were built on site and laid in the ground as the crew moved along the ditch. Allen's model was adopted by many other towns looking to improve their water supply systems.

After Denver and Auraria merged to become Denver City in 1860, the *Rocky Mountain News* published the following article on August 1: "Cherry Creek appears to present a rather serious problem, for we have had a demonstration of what may be expected from a heavy rainfall on the Divide [the Palmer Divide, south of Larkspur], though we are not yet inclined to believe the Indian claims that the whole settlement is subject to flood."

Denver was known as one of the leaders in water distribution. This reputation was due in part to Mr. C.P. Allen, whose pipe design using wooden staves was considered one of the best in the country. Allen's model was adopted by many other towns looking to improve their water systems. *Courtesy Denver Water Board.*

Just four years later, on the night of May 19, 1864, a local professor who witnessed a flood reported:

> *A frightful phenomenon sounded in the distance and a shocking calamity presently charged upon us…the great noise of might waters…rushing down upon us, now following former channels, and now tunneling direct though banks and bottoms, a new channel of its own…sweeping tremendous trees and dwelling-houses before it, a mighty volume of impetuous water… leveling all things in its march. The dear old office of the Rocky Mountain News…down it sank, with…General Bowen's law office…for four or five hours up to daylight, the floods in Cherry Creek and the Platte were growing gradually, spreading over West Denver and the Platte bottoms.*

That deluge was not the end of flooding in Denver. Much to the annoyance of residents, Cherry Creek overflowed its banks five times—on May 22, 1876; May 22, 1878; July 26, 1885; July 14, 1912; and July 28, 1922. Each time, the river carried debris that smashed into bridges, washing them away. Anything in the river's path—railroad tracks, carriages, automobiles and lives—was lost.

In 1912, a flood commission was appointed by the mayor to establish if anything could be done to prevent further destruction. The commission members offered the following:

The first flood of which we have any record occurred on Thursday and Friday, May 19 and 20, 1864. The flood reached its maximum height about 2 a.m., May 20. This height it maintained until about 7 a.m., at which time the waters began to recede. This flood had its origin at the upper end of the Cherry Creek watershed, being occasioned by a heavy fall of alternating hail and rain, occurring on the afternoon of May 19. This storm extended over the watershed of Plum Creek also, which discharged into the South Platte River, making an unprecedented height.

In 1890, promoters and entrepreneurs south of the city decided to build their own water supply. The project was a disaster in the making, and had it not been for an astute and responsible telephone operator called Nettie Driscoll, many lives would have been lost.

The project, known as the Castlewood Dam, was completed in 1890, but there were major concerns about quality during its construction. There had been reports that the dam had leaked almost from the outset. Chief Engineer A.M. Welles had been criticized to the extent that he felt that he needed to defend himself and the project. He wrote to the *Denver Times*: "The Castlewood Dam will never, in the life of any person now living or in generations to come, break to an extent that will do any great damage either to itself or others from the volume of water impounded, and never in all time to the city of Denver."

The hastily constructed dam south of Denver was a disaster in the making, and had it not been for a quick-witted telephone operator, many lives would have been lost in the flood of 1933. *Left to right*: Halley Oltman, Alice Wolfensberger and an unidentified man. *Courtesy Douglas County History Research Center, Douglas County Libraries, #93005.040.003.*

Welles was wrong. Severe storms raged over Colorado for the first two days of August 1933. Then, on the night of August 3, the six-hundred-feet-long and seventy-feet-high waterlogged dam burst, and a wall of water fifteen feet high surged toward the city of Denver.

Time magazine reported on August 14, 1933:

> *Thundering like a mountain on the move, the wall of water surged through Parker, tumbled down Cherry Creek toward suburban Denver. Logs, tree-trunks, tons of debris were swept along as the billion-gallon deluge widened out to more than a mile. Cherry Creek was a battering-ram of water, boiling over its embankments. At 7 o'clock it burst into Denver, ripped out six bridges in swift succession. Just ahead of it were police cars and fire engines, sirens a-scream, racing the residents to safety. A stampede of 5,000, many clad in night cloths, fled from the lowlands.*

The battle to provide water to a growing population has always been difficult. An early pioneer to Denver, Francis Parkman, was delighted upon his arrival at Cherry Creek to find "cherries, plums, blackcurrants and gooseberries. No water in the creek—dug holes and got some."

During the 1860s, everyone drank freely from Cherry Creek, including the wild and domestic animals that also urinated and defecated in that very same source. Pigs ran loose in the city, and concerned residents feared that the newly completed city ditch would be a breeding ground for a cholera epidemic. The authorities took quick action by requiring pigs to be penned at all times.

Enterprising men saw the need for cleaner, better-tasting water. It was a lucrative business. Local men had artesian wells dug and then bottled the water, which they sold to residential homes and businesses. They quickly moved to water wagons and had water boys carry the water in buckets into homes and businesses. The buckets contained 2.5 gallons each, and the boys received a nickel for delivery. They charged a dime if they had to carry the buckets up another floor.

When the residents of Denver were given the opportunity to have water piped directly into their homes, many decided against it. Perhaps the reason was cost or the fear of contamination as water passed through the pipes. Either way, typhoid fever was something everyone dreaded. Still, not much was known about the disease, or how it spread. Newspaper articles during the 1880s surely carried the story of Mary Mallon, the first person in the United States believed to have been an unknown carrier; she infected as

Newspaper stories from the East Coast reported that contaminated water had likely been the cause of the typhoid and cholera outbreaks. In 1906, Denver water was being chlorinated to help prevent cholera and typhoid and was tested regularly to ensure quality. *Courtesy Denver Water Board.*

many as fifty-three people. Mary was a fifteen-year-old Irish immigrant who first worked as a maid but then as a cook on the East Coast. Everywhere she worked, the people of the household became infected; three died, including one little girl.

Mary had inherited the disease from her mother, who had passed it on to her infant daughter. An unwitting carrier, Mary was never sick herself and challenged the authorities' belief that she was infected, but to no end. They removed her gallbladder anyway, a risky operation, and tests proved that it was literally teeming with the typhoid bacteria. She lived the rest of her life in relative seclusion, almost a prisoner in her own house, and was never allowed to work again.

Another deadly disease that must have struck fear in any community was cholera. Unlike typhoid fever, with which a carrier can appear perfectly healthy, anyone who contracts cholera is dead within hours. These diseases, as well as tuberculosis, where people walked around with a bloody handkerchief to their mouths, must have struck fear into the hearts of the people of Denver.

The need for good, clean water was imperative. From 1870 until the mid-1890s, at least ten water companies were formed. Some merged and

It appears that Countess Murat—a fair-haired, blue-eyed beauty—was well liked in the community. She had set down roots, unlike some people who gave up easily and returned home. These people were nicknamed "go backs," a somewhat derisive term meant to embarrass those people who were considering leaving. Katrina further endeared herself to the people of Denver by sewing the first Stars and Stripes flag to fly over the town, giving her the title of "Mother of Colorado."

Countess Murat was sixty-three years old in the spring of 1887 when she decided to leave Denver and her husband to travel the fifty miles south to Palmer Lake. She immediately fell in love with the area and built a little cottage just below Sundance Mountain. Using her past experience in Denver, she worked hard and used her home as a guesthouse, cooking and cleaning for her visitors. She also had a well dug close to her house to provide cool, sweet water for her guests, but she allowed other residents to use it at will. Lucretia Vaile and her sister, residents of Palmer Lake, often called on Mrs. Murat (as she preferred to be called) for permission to use her well. Lucretia recalled that Mrs. Murat was always most gracious and accommodating, but she doubted that she was worthy of the title Countess Katrina Murat: "She was always very nice about letting me get it and finally won my reluctant conviction that she was really a countess—though I was pretty sure then that countesses were about as rare as fairies in Colorado."

During the following twenty-three years, the people of Palmer Lake watched over their countess. They had water piped directly to her house and watched over her health. As she grew older, she suffered from rheumatism, and her eyesight was poor. She had many visitors who traveled by train from Denver

The young Countess Murat was said to have fashioned the first Stars and Stripes to fly over the city, albeit for a few days. Katrina Murat became the darling of Denver and was given the title "Mother of Colorado." Courtesy Lucretia Vail Museum, Palmer Lake.

to see the "Mother of Colorado." She supposedly always greeted her visitors with grace and bearing.

There are interesting stories surrounding the countess and count. Some say that the count married beneath his station in life and therefore escaped family criticism by leaving his ancestral home. However, Katrina appeared to be the practical wife who cooked and cleaned, while he was the more flamboyant of the two, dressed impeccably and had a high opinion of himself. Several years later, Countess Murat left her husband in Denver and moved south, but perhaps she did so with a little financial help. In those early years, expenses were often paid in gold dust. It is rumored that Katrina sewed some of that dust into her clothing for safekeeping. This, of course, added much weight to her person, and on one particular occasion, it supposedly took several men to hoist her into a wagon. Countess Katrina died while living in Palmer Lake on March 13, 1910. Henri died penniless in Denver and is buried at Riverside Cemetery.

Countess Katrina Murat was sixty-three years old when she left her husband after many years of marriage and failed businesses. In 1887, she moved to Palmer Lake, built a little cottage, dug a well and opened her home as a guesthouse. *Courtesy Lucretia Vail Museum, Palmer Lake.*

Baby Doe Tabor

Baby Doe was someone who rose from rags to riches only to fall again into poverty. She did indeed die in a cold shack above the Matchless Mine, rags wrapped around her feet in an attempt to keep warm and her arms folded across her chest. Suspicious neighbors became concerned when they could see no smoke coming from her chimney, and they went to investigate. They found Baby Doe lying on the floor, frozen to death.

Elizabeth McCourt was born on September 25, 1854, one of fourteen children to a staunchly Catholic family. By all accounts, she was a beautiful child and learned quickly that her looks would carry her far. She married

young, to a man called Harvey Doe, whose father had half an interest in a gold mine in Colorado. Together the young couple left their Wisconsin home and headed west to the Rockies, where Harvey's father hoped that his son would manage his share of the mine. Things did not go as planned. Baby Doe had been somewhat coddled by her family, who considered her "too pretty to work." However, she did work alongside her husband and became the darling of the miners, who affectionately gave her the nickname "Baby Doe."

It was not long before Baby Doe became disillusioned with her life and marriage and met Horace Tabor. He was a very rich, influential man married to Augusta Tabor and almost twenty-five years her senior. He was well established in society, with a successful career as a politician and a silver magnate. At first, Baby Doe and Horace Tabor tried to keep their relationship a secret, but wagging tongues forced them through divorces and marriage.

Tabor and Baby Doe made an unusual couple walking down the street, attending operas and dinners together. All eyes were on Baby Doe and her older and more experienced husband as he showered affection on his beautiful young wife. The people of Denver shunned Baby Doe as "the other woman," rallying instead around the more austere Augusta. She had given Horace a son, Maxey, a colicky child who suffered from "fever and ague" and had stood by her husband in Kansas during the hard times when he had worked as a stonemason and rancher. When word arrived from the Rockies that men could earn up to ten dollars per day mining, Horace decided to leave his farm and took his wife and son to Colorado to seek a better life. It was a hard journey for Augusta, especially with a baby, but she stood by her husband, and that was something that endeared her to Denverites. The men still did business with Horace, but the women scorned Baby Doe.

Life was good for the new Tabor couple, despite the specter of Baby Doe's divorce. Many questioned the legality of the marriage. How could a practicing Catholic obtain a divorce? Nevertheless, three children were born to Horace and Baby Doe, one stillborn son and two beautiful daughters, Lily and Rosemary.

Horace was a wonderful father and doted on his two daughters, giving them everything money could buy, but then in 1893, there was a sudden drop in the price of silver, and everything changed. The price had plummeted to such an extent that instead of reaping thousands of dollars per day, now Horace saw figures in the single digits. Life as the Tabor family knew it was over, but there was more bad news to come. Horace became sick one day with what he considered to be a "bilious" attack. Instead, it was a bad case of appendicitis that flared into

peritonitis, and within days he died. One of his last wishes was a plea to Baby Doe to "hold on to the Matchless."

Baby Doe and her daughters were penniless, their lives in ruins. Adding insult to injury, she knew that Augusta was financially sound and living comfortably on her settlement from the divorce. Baby Doe took refuge with various family members in Chicago, ending with widower John Last, who had married Baby Doe's sister, Cornelia.

A romance began to develop between John Last's son and Lily, who were essentially first cousins. They married, and a despondent Baby Doe returned to Colorado with her youngest daughter, Rosemary.

Estranged somewhat from her eldest daughter, Baby Doe turned her attention to raising Rosemary, a headstrong and beautiful young woman. Eventually, Rosemary left, too, and lived in a seedy apartment in Chicago, where she assumed a different name, perhaps hoping to escape her past. She earned a living doing various jobs and even appeared on the stage. Then, one day in 1925, she suffered a severe scalding in her apartment and died. Baby Doe would never admit that the person who had died in that apartment was her daughter, preferring to believe that her precious Rosemary had entered a convent and therefore was serving God.

Baby Doe Tabor rose from relative obscurity, married one of the most influential men in Denver and enjoyed the finer things in life only to lose it all. She froze to death in a little cabin above the Matchless Mine. *Courtesy Donald Wallace.*

Lily tried to put her old life behind her. On more than one occasion, she denied that she was the daughter of the infamous Baby Doe and the once fabulously rich silver magnate, Horace Tabor. However, she did have communications with her mother and even invited her to see her grandchildren—Caroline, born in 1908, and John, born in 1910—in Milwaukee, where Lily and her husband had moved.

Baby Doe lived alone in the shack for almost thirty-five years until her death in 1935. She would never accept charity of any kind, although when she visited Denver and stayed at the Brown Palace Hotel, the bill was destroyed "because it was never paid." One cruel observer who saw her walking around town with her black parasol said that she was "painted like an Easter egg, red cheeks." Regardless, Baby Doe's life has been immortalized in books, ballads and an opera.

Emily Griffith

The tragic deaths of Emily Griffith and her disabled sister, Florence, are still clouded in mystery to this day. One man, Fred Wright Lundy, was considered the prime suspect in their deaths. Two months after the murder, his body was pulled from South Boulder Creek, an apparent suicide.

Lundy and Griffith had been teachers in Denver and had known each other for almost twenty years. Some people believed that Lundy had romantic interests toward Emily and felt she had been dealt a severe blow having to care for her semi-invalid sister. He was known to complain about the state of affairs Emily had to endure, caring for her sister in the tiny cabin in Pinecliffe. Indeed, on one occasion, he even mentioned that they would be better off dead than living they way they were.

By all accounts, Lundy was a quiet man, retired many years from his teaching position. Some people in Pinecliffe called him "Old Fred," a man who had interesting stories to tell to those who wanted to listen. O.C. Zerbst, who ran the local general store, remembered that Lundy would enjoy sitting by his potbellied stove and visiting with neighbors. Others considered him a reclusive man, one who enjoyed his own company, liked to walk about town and then go home and read his beloved books.

For almost eight weeks, the little town of Pinecliffe, Colorado, was awash with the horror of the killings. Both women had been shot in the back of their heads, almost execution style. People locked their doors and were watchful and afraid, especially since Lundy had disappeared shortly after

the sisters' bodies were discovered. Authorities found a note in Lundy's car that they considered to be proof that he had taken his own life, although there was no mention of the Griffith sisters. He had also sent an obscure letter to his brother, Jay M. Lundy, advising him of how to dispose of his body, should it ever be found.

The *Denver Post* reported on Sunday, August 17, 1947, "Braving treacherous rapids, Boulder county authorities and Denver detectives haul the body of Fred Wright Lundy ashore." Evidently, the body had become wedged under a large boulder, and had it not been for two sharp-eyed young fishermen, James Walter Oakes and Charles Steinshouer from Lakewood, the body might never have been found. They collected a $100 reward for the discovery.

It was a sad end to Emily's life. She was woman who had accomplished so much during her lifetime. Born in Cincinnati, Ohio, on February 10, 1868, she was the eldest of four children born to ailing parents. At fourteen years of age, she began teaching in a sod schoolhouse in Nebraska and immediately knew that she had found her vocation. Besides supporting her family emotionally and financially, Emily loved her job. Through her students, Emily learned that many of their parents did not understand the English language and therefore could neither read nor write. They were mostly immigrants, intelligent and hardworking men and women who wanted to make a difference in their adopted country. The concept of providing a school for adults slowly formed in Emily's mind, and eventually her dream would materialize in the Emily Griffith School of Opportunity.

When the school was opened in Denver on September 7, 1916, Emily was nervous and worried that it would not be a success. She should not have been concerned. The people came by the hundreds and then by the thousands. They biked to school and walked or came by streetcars, flooding into the building and overwhelming Emily and her teachers. They came to learn English, as well as skills ranging from hat making to typing. During the first week, Emily had almost 1,500 students, 100 of whom wanted to learn how to type. The single typewriter was kept busy thirteen hours a day as pupils worked in shifts.

Many of the students were from Italy. Salvatore "Sam" Natale Albi learned English and meat cutting at the school. Joseph "Joe" Vincent Calabrese earned his high school diploma and went on to Parks Business School. Later, he entered the political arena and served in the Colorado legislature. Other men such as Umberto Morganti attended the school, but as teachers. Morganti was a playwright, publishing three plays in 1945.

Women joined the ranks of students, too. Nancy Lena "Lee" (Garramone) Walrath enrolled in the beauty school, learning skills that would sustain her and her family for the rest of their lives.

The Emily Griffith School of Opportunity became hugely successful and was nationally known. The Colorado Business Hall of Fame honored her as one of five people who "possess qualities of commitment, dedication and success to the business community and the state of Colorado."

Why Emily's life ended in such a tragedy is anyone's guess. She and her sister lived on a forty-dollar stipend from the Denver Public School District. They appeared content in their tiny cabin until their lives were taken from them. Some say that it was a "mercy killing" by Fred Wright Lundy, who wanted to put the sisters out of their misery. Others say that Lundy was infatuated with Emily and visited the sisters on many occasions. Either way, the police believed that Lundy was indeed the killer and that he became remorseful and took his own life.

Margaret "Unsinkable Molly" Brown

Born in Hannibal, Missouri, close to the Mississippi River and boyhood home of Mark Twain, Margaret Tobin was a woman well ahead of her time. She was one of four children born into a poor Irish family. She was ambitious and wanted a better life for herself and her family. At just eighteen years of age, she and her sister left their home and traveled west, settling down in Leadville. It was not long before Margaret noticed James Joseph Brown, who worked as an engineer for the Little Jonny Mine. They fell in love and were married in Leadville's Annunciation Church on September 1, 1886. This had not been part of the plan. Remembering her roots, and the poverty that she and her family had endured, Margaret had intended to marry a rich man, one who could help her and her family financially. Instead, she had married for love, and before long, the happy couple had two children, a boy and a girl.

By all accounts, James Joseph Brown, or "J.J.," as Margaret affectionately called him, was a skillful engineer with a keen eye and a good head on his shoulders. It was these attributes that helped Brown and others find the mother lode for the investors. For his efforts, he was given 12,500 shares and a seat on the board. This was a life-changing event in the Browns' lifestyle. They moved to Denver, bought a fine house at 1340 Pennsylvania and expected to be accepted by polite society. But they were not.

Maybe it was due to their newly acquired money or the fact that they were strict Catholics; perhaps it was because Margaret, being of a particularly flamboyant character, simply did not fit the "the Sacred 36" profile. The Sacred 36 was a group of thirty-six members of the Denver elite that met regularly at Crawford Hill Mansion to play bridge.

Snubbed by the elite of Denver, Margaret gave parties of her own, sweeping down the impressive staircase in her home dressed in her customary silk dresses, her colorful hats adorned with ostrich and peacock feathers. At least two of Margaret's hats had been made by Kate Ferretti, who had attended the Emily Griffith School of Opportunity and then apprenticed with Mrs. Molly Mulroy's Villa de Paris, a well-known millinery shop in Denver. Ten years later, Ferretti was designing hats for the elite ladies of the city, including Margaret Brown:

Margaret "Unsinkable Molly" Brown was born in Hannibal, Missouri. One of four children born to a poor Irish family, she became famous for her role during the sinking of the *Titanic*. *Courtesy Donald Wallace.*

> *One was a big broad-brimmed sailor with a crown five inches high. It was covered in real leopard and it had a black ostrich plume sticking up high on one side. Mrs. Brown loved that hat and she went next to a furrier and had a leopard skirt made to match it. The other hat I remember was a large brown felt, and across the front, I had a big white bird with wide-spread wings. It was gorgeous.*

Margaret began to self-educate and learned at least four languages. She took an interest in everything. During World War I, she helped organize

actors and singers to entertain the troops, and had Mark Twain's books translated into Braille for soldiers who had been blinded by mustard gas. Brown was active in the women's suffrage movement and in working with the poor, but it was the sinking of RMS *Titanic* that brought her notoriety. On April 15, 1912, soon after the so-called indestructible ship hit an iceberg and was sinking fast, it was Margaret who kept her head and helped load women and children into the lifeboats. Even while in a lifeboat herself, she tried to help those in the water and keep them alive until they could be rescued. Newspapers were full of Margaret's valiant help. She dined with the president of the United States and with dignitaries and other influential people. Upon her return to Denver, she was flooded with the invitations that had been much sought after. She traveled around the world and continued her education, but her marriage was failing. Margaret and J.J. separated after twenty-three years of marriage. Margaret retained the house on Pennsylvania and received $700 per month. This allowed her to continue the social work that she loved and also travel the world.

Clara Brown

Clara Brown was an extraordinarily warm and loving woman, despite the fact that she had been a slave for most of her life. When she was old enough, she married another slave, and together the couple had a daughter, Liza Jane. It was not long before Clara, her husband and child were all sold, each to a different family.

Later, Clara discovered that her husband had died, but she had no information on her baby girl, her whereabouts or whether she lived or had died. In 1859, Clara's owners in Kentucky, thankful for her service, freed her and provided enough money for her to reach Leavenworth, Kansas, where she hoped to travel west. Unfortunately, she did not have enough money for the fare and so signed on as cook on a wagon train to Denver. Eyebrows were raised, but Clara's bright and sunny disposition soon won over those people with prejudices. During the long journey, when someone was sick, it was Clara they called on for help. It was Clara who cooked the meals for the wagon master and his crew. It was Clara who tended to their wounds and who sat up nursing the sick. They welcomed her experience, and she shared her knowledge gladly.

Upon her arrival in Auraria, she was introduced to Herr Reitze, the owner of the City Bakery. He proudly announced that even though Auraria was a

fledgling town, a church was about to be built. Being a devout Methodist, Clara was delighted to hear the news and showed her enthusiasm. Then the owner asked her what she planned to do now that she had arrived in the new town. When she replied that she had no job and no money, he offered her a job in his bakery. Clara was almost speechless and expressed her wonderment at being offered a position of employment from a total stranger. Reitze responded, "I am not a stranger, Sister Brown. Aren't we brothers and sisters in Christ?"

Like many others, Clara's ultimate goal was to get to the mountains. She knew that this was where the majority of workers were needed. She listened to the miners' complaints while she cooked. They needed someone to do their laundry and iron and mend their shirts. She saved her money but knew that a former slave would never be allowed to purchase a ticket on a stagecoach, and so she devised a plan. She spoke to a prospector, promising to pay him the fare if he would take her to Central City under the guise that she was his hired help. Once there, she rented a small cabin and started her own laundry business, carefully saving as much money as possible so that she could go in search of her daughter, Liza Jane.

Years passed, and finally Clara had saved enough money to make the journey back to Kentucky. The family who had owned her were genuinely pleased to see her but gave little hope of her ever seeing any of her relatives, least of all Liza Jane. Despondent, she decided to use the money she had saved to take sixteen former slaves back to Colorado, certain that she could help them find work and a new life.

In 1882, Clara, now an old and feeble woman, had given up hope of ever seeing her daughter again. But a strange thing happened. A friend in Council Bluffs, Iowa, wrote to Clara, telling her that in town there was a woman called Liza who was in her late fifties. Liza was a laundress by trade and had a daughter called Cindy. There were simply too many coincidences for Clara's liking, and so she borrowed some money and set off for Council Bluffs. It was indeed her daughter, Liza Jane. After fifty years, mother and daughter were reunited. News of the heartbreaking story brought tears to peoples' eyes, and they dug into their pockets for the return fare to Denver for Clara and her granddaughter. Cindy decided to stay in Denver and built up her own small business.

In the summer of 1885, Cindy summoned her mother to come quickly, as grandmother was very ill. Upon Liza Jane's arrival, they dressed Clara in a fine calico dress with a starched white apron and took her to the

annual banquet of the Society of Colorado Pioneers. There she was eulogized for her dedication, love and loyalty. She died the following month at the age of eighty-five.

Isabella Bird

Although not technically a resident, Isabella L. Bird lived in Estes Park and visited Denver often. She wrote letters to her sister, Henrietta, who lived in England. The letters must have been the source of concern one moment and fear the next as Isabella describes her adventures from the Sandwich Islands (Hawaii) to Colorado. Dressed in her customary "Hawaiian riding clothes," she arrived in Colorado and told her sister that the place was "no region for tourists and women." It is hard to imagine that a woman riding on her own through such wilderness could have emerged unscathed, but she did. We are blessed with a fascinating account of her journey, recorded with humor and a keen eye in her letters to her family. She noted on one occasion that most men wore boots or shoes "but they don't necessarily match." She could be quite caustic at times and other times soft and compassionate.

When she reached Denver, she was struck by the beauty of the mountains and decided to make Estes Park her temporary home. As word of her journey spread across Colorado, so did the interest. Her reputation preceded her, and she was known as "the English woman" who rode mostly alone on her trusty horse, Birdie.

Not much is known as to why Isabella Bird undertook such a perilous journey on horseback. She was born into an upper-middle-class family at Boroughbridge Hall in Yorkshire, England. Tom Richardson, of the North Yorkshire County Record Office, cites Boroughbridge Hall as the ancestral home of the Wilkinson family, but in 1805, the Hall was passed to Reverend Marmaduke Lawson. The Oxford Dictionary of National Biography suggests that Isabella's mother (Dora) was the daughter of Reverend Lawson—therefore Isabella had led a life of relative comfort and privilege before embarking on a dangerous journey into the Rocky Mountain region.

When Isabella arrived on the outskirts of Denver, she came upon a "den," the home of a man called Mountain Jim. She described the man and his home in several letters to Henrietta:

> *The big dog lay outside it in a threatening attitude and growled. The mud roof was covered with lynx, beaver, and other furs…roused by the growling*

of the dog, his owner came out, a broad, thickset man, about the middle height, with an old cap on his head, and wearing a grey hunting suit much the worse for wear…a diggers scarf knotted round his waist, a knife in his belt, and a "bosom friend," a revolver, sticking out of the breast pocket of his coat.

Bird's account of the trapper's lifestyle provides valuable insight into the lives of men who lived off the land, as well as the dangers they encountered. She described his flaxen-colored hair that hung in ringlets from his hat. She continued her letter home:

His face was remarkable…he must have been strikingly handsome, with well marked eyebrows, a handsome aquiline nose…one eye was entirely gone, and the loss made one side of his face repulsive, while the other might have been modeled in marble. He told me that the loss of his eye was owing to a recent encounter with a grizzly bear, which, after giving him a death hug, tearing him all over, breaking his arm and scratching out his eye, had left him for dead.

The letters Isabella sent home must surely have concerned her sister Henrietta and their father, Reverend Bird. In them, she told of the financial crash—that the banks had suspended all business and would not give her "greenbacks" for her English gold. She told them that her stockings were full of holes and were threadbare but that she had no money to purchase new ones, and nobody could get a cent from the banks. More troublesome to her father must have been the news that the Indians had taken to the war path and were "burning ranches and killing cattle."

The situation must have calmed down because in later letters Isabella told of her life in a cabin in Estes Park. Here she was happy and could be seen riding her favorite horse, Birdie. She wore her Hawaiian riding outfit that included a short jacket fitted at the waist, a skirt that reached to her ankles and full Turkish-style trousers that were gathered at the ankle and covered her riding boots.

Isabella's description of Denver in 1873 provides a very personal glimpse of those early years. She is a little harsh in her description of the people and their appearance and manners, and she complained of their drinking habits and swearing; however, almost in the same breath, she described the beauty that surrounds her and obviously enjoyed meeting Governor Hunt and Mr. Byers of the *Rocky Mountain News*.

The female adventurer Isabella Bird fell in love with Estes Park and decided to live in a small cabin nestled in the mountains. In 1873, she wrote letters to her sister in England that included caustic remarks about the city of Denver and its people. She wrote of meeting Englishmen, whom she called "high toners" because they affected mannerisms above their station in life. *Courtesy Roxanne O'Rourke.*

Courageous and quick-witted, she would notice the slightest details of an individual and then write home. She had a dry sense of humor and made fun of the "high toners," those men with English accents who, for one reason or the other, put on airs and graces to impress those around them.

It seems that the adventurer loved the Rocky Mountains, and at one point in her letters, she remarked, "As I rode into Denver and away from the mountains the view became glorious, as range above range crowned with snow came into sight."

Minnie Reynolds

Minnie Reynolds, a fearless advocate of women's rights who fought against racial discrimination, was also a suffragette, a newspaper reporter and a founding member of the Denver Woman's Press Club. She was a feisty and determined young woman who secured her position at the *Rocky Mountain*

Minnie Reynolds is the founding member of the Denver Woman's Press Club, which began in 1898. More than thirty years later, she was still passionate about the rights of women and the poor. *Courtesy Denver Woman's Press Club.*

News by offering her work under the name of M.J. Reynolds. The editors who reviewed her credentials assumed that she was a man and hired her. It was only when she presented herself in person that they realized their mistake, and she was relegated to the society page.

Reynolds took an interest in every aspect of life and society. She wrote passionately about the plight of women, the downtrodden and the poor, and she spoke for those who did not have a voice. In 1893, women gained the right to vote in Colorado, a victory for Minnie and others who had fought hard for women's rights. It must have been a poignant moment when those ladies entered the voting booth for the first time. More than thirty years later, Minnie, still passionate about the suffrage movement, was reading a book by Carrie Chapman Catt entitled *Woman's Suffrage and Politics* and said, "Part of it I read with tears in my eyes, part with curses on my lips and sometimes I would get up and walk up and down the floor. I saw so much of it…I was in Colorado, New York, New Jersey, Washington and Iowa campaigns….What women have had to go through to get where they are. The youngest don't know."

The sign reads, "Down with Men." Three women from the Denver Woman's Press Club appear to be having fun at the expense of men while they enjoy a pot of tea. Minnie was instrumental in securing the rights of women to vote in 1893. *Courtesy Denver Woman's Press Club.*

In 1898, Minnie was contacted by the General Federation of Women's Clubs, which was planning on having its biennial meeting in "far west" Denver. A representative asked Minnie if there was a society or club in her city specifically for female professional writers. At that time, there was no such thing, but rather than admitting to that fact, she went into action immediately, called her friends and then quickly wrote a constitution and bylaws for a hastily assembled organization. The handwritten minutes taken at the meeting mentioned the following women: "[F]our matrons, Mrs. Hill, Mrs. Wixson, Mrs. Hawley, Mrs. Kincaid and four Misses, Reynolds, Sapp, Hall and McMechan." With that, the Denver Woman's Press Club came into being. The club magazine reported:

> *On the fair but somewhat windy afternoon of March 18, 1898, the writers gathered up their "voluminous skirts" mounted their bicycles and pedaled through Capitol Hill to 1424 Clarkson Street, the home of Helen Wixson. What with the hills, the skirts, the wind and the corsets clamped around their ribs, they must have needed a few moments to catch their breath, but then they figuratively rolled up their mutton sleeves and went to work.*

The first thing on the agenda for the newly formed club was to entertain the Federation ladies when they arrived in town. Wanting to set a good example of "far west" hospitality, the Denver Woman's Press Club honored them with rooms on the eighth floor of the Brown Palace Hotel. The Federation entourage was also entertained at the elegant home of Charlotte Pierce Gallup, who had recently arrived to assist her brother, John Pierce, and who had married Avery Gallup. By all accounts, it was a stylish affair as the women donned their best frocks and hats for the occasion.

During the first year, the club admitted two honorary members: Mary Elitch Long, whose husband founded Elitch Gardens and whose portrait still hangs in the DWPC clubhouse to this day, and Charlotte Pierce Gallup, who, with her husband, started Denver's parks and greenhouses.

As the club grew in size, members longed to have a permanent home. After months of searching, they learned that the house of artist George Elbert Burr at 1325 Logan was available. The purchase price was $9,000, which was an enormous amount of money in the early 1920s. However, once the members saw the beautiful house that doubled as a studio and home for the talented Burr and his wife, they simply had to have it. Fundraising events began in earnest. On January 11, 1924, the Denver Woman's Press Club ball raised $3,000, enough money for a down payment on the home; the balance of the purchase price had to be paid within five years. On October 21, 1924, the members of the DWPC met in the clubhouse for the very first time. Minnie Reynolds died on May 29, 1936, but even today, members look back fondly at her efforts and accomplishments. Her fledgling professional writer's society now boasts more than two hundred published writers who are active in the community, providing scholarships, workshops and support to various charitable organizations.

Helen Hunt

Helen Hunt was born in Amherst, Massachusetts, in 1830. She was a happy and lively child interested in everything that went on around her. Her love of writing came late in her life after she had married an army officer, Edward Hunt. They had two sons together, one of whom died in early infancy. Life was not kind to the young Helen—her husband was killed as he tested a submarine gun, one of his own inventions. Two years later, another blow was struck when her second son, Rennie, contracted diphtheria at the tender

age of nine and died. It was at this time that the now childless and widowed Helen began to write prolifically.

Since writing was not considered a suitable profession for women, she wrote under the pen name of "H.H." She wrote children's stories, poems and articles and generated enough income to sustain a decent living and see some of the world. Later, she turned her attention to fiction and used the pseudonym "Saxe Holm." The public enjoyed the stories tremendously, and speculation grew as to the identity of the author. It was years before Helen divulged the truth, but then tragedy hit again.

Helen became ill with a case of "galloping consumption," otherwise known as tuberculosis, a disease that her mother had been afflicted with while expecting her young daughter. Helen's physician advised her to move to Colorado, where other "wealthy lungers" had moved and where some had benefited from the climate. She settled in Colorado Springs, and once there she caught the eye of a man five years her junior, William S. Jackson. By this time, she was an accomplished writer, well known in literary circles. Helen's zest and her love of life and passion appealed to her young suitor. They married in 1875, and although Jackson was a wealthy man, he purchased a small but very well-built home for his wife on the corners of Weber and Kiowa Streets.

The builder of the Jackson home, Winfield Stratton, a divorced carpenter with little money, would later become a millionaire almost overnight through his ownership in the Independence Mine. He was not comfortable with his

Helen Hunt was a prolific writer who wrote under pseudonyms because writing was not considered suitable for a woman in the 1870s. She became an advocate of Native Americans, challenging the government's violation of their treaties. She particularly targeted Carl Schurz, U.S. secretary of the interior, and stated that he was "the most adroit liar that I ever knew." *Courtesy Special Collections, Colorado College.*

newfound wealth and notoriety and said, "Too much money is not good for any man…I have too much and it is not good for me."

Two years after moving into her new home, Helen attended a lecture in Boston at which Standing Bear, chief of the Ponca tribe, described his tribe's treatment at the hands of government agents. Immediately, Helen went into action on behalf of all Native Americans, challenging the government's violation of Indian treaties, sometimes complaining that the ink was barely dry before the government reneged on its word. She particularly targeted Carl Schurz, U.S. secretary of the interior and complained that he was "the most adroit liar that I ever knew."

Helen remained an activist all her life and eventually published her first book under her own name, *A Century of Dishonor*, in which she described the plight of Native Americans. She died in 1885 of stomach cancer.

Did You Know?

In 1858, the closest post office to Denver was at Fort Laramie, two hundred miles north.

William N. Byers, founder of the Rocky Mountain News, published the first edition of his newspaper, the *Rocky Mountain News*, on April 23, 1859.

The arrival in Denver of the first railroad express was on May 7, 1859, and comprised two coaches. It was the first of the Leavenworth and Pikes Peak Express service.

The first mayor of Denver was John C. Cook, who was elected on December 13, 1859.

In 1859, Daniel Oakes published a guidebook about the Colorado gold fields. The book encouraged men to leave their homes and even their families in search of gold. Most were not successful, and resentment followed in the form of burial effigies, like one that read: "Here lies D.C. Oakes, who was the starter of this damned hoax."

Dr. Nickles Deutsch was the first allopathic physician in Denver in 1859. He also ran a barbershop.

Denver's first duel, fought between W.P. McClure and R.E. Whitsitt, took place on October 19, 1859.

The first "postman" was a trapper by trade but undertook the responsibility of delivering the first mail in the area. Jim Saunders started his delivery on November 23, 1859, and completed it on January 9, 1860.

In 1860, the interest rate charged by Denver banks was between 10 and 25 percent per month.

The first coach carrying mail for the U.S. Post Office arrived in Denver on August 1860.

In 1860, Abe Lee found gold in his Leadville mine and yelled, "Lord A'Mighty! I've got all Californy in my pan!" This exclamation brought literally thousands of new prospectors to Colorado.

In 1861, Mademoiselle Carolistra performed a tightrope act over the 1500 block of Larimer Street.

Wagon trains began operation between Denver and mining settlements in 1865.

As the populace of Denver grew, so did the need for horses. The Gully homestead, located at Chambers and Mississippi, raised a particularly fine breed of horse that was part Morgan and part mustang. The family's horses were bought by the Tivoli Brewery, as well as other businesses that needed a strong, durable horse to pull wagons of produce. In 1866, there were five livery stables listed in the Denver Business Directory.

Not everyone found gold in Colorado. Many families disillusioned with their lives "out west" sold everything they had to raise the money for their homeward journey—those people were called "go backs."

People from the East Coast, England and mainland Europe were often given nicknames because of their accents and the fact that some appeared to put on "airs and graces"—names like "high toners" and "self risers." Other nicknames were given to gangs or hooligans who arrived in Denver from California. These men were called "bummers" presumably because they did not work and "bummed" a living by breaking into homes and stealing clothes from clotheslines.

In 1863, telegraph lines were established between Denver and New York. Messages were sent at a cost of almost one dollar per word.

On February 19, 1866, the Denver Police Department started using horse-drawn patrol wagons.

Despite the efforts of a volunteer firefighting department that had been formed in 1862, those men were not able to contain the many fires that occurred in 1863. Some suspected that an arsonist was at work, but nothing could be proved. The townspeople knew that they needed a well-organized firefighting department, and so a meeting was held on March 25, 1866, in the Davis and Curtis grocery store. George W. McClure was made foreman, and he went home and built the first homemade hook and ladder cart.

In 1869, a group of men came together to form the first gas company in Denver. William N. Byers, owner of the *Rocky Mountain News*; Colonel James Archer; Walter Scott Cheesman; and other influential men came together

The alleyways behind some of the older homes in Denver do not lead anywhere. In fact, they were simply "turnarounds" for carriages and the stabling of horses. Now they are used as common areas, parks, garages or studios. *Courtesy Donald Wallace.*

to form the Denver Gas Company. Every night at dusk, and again at dawn, a lamplighter walked the streets. Over his shoulder, or in a wheelbarrow, he carried a short ladder to use in turning on the hissing gas and lighting the flame—or extinguishing it.

Have you ever tried to take a shortcut down an alleyway only to find that it is a dead end? In fact, many of the nicer, more elegant homes that were built in the late 1800s provided access to the back of the house for deliveries and room for the horse and carriage to turn around. An exploration of some of these alleyways reveals that the stables have since been made into studios or garages, but the "hitching rings" are still visible on the walls of some alleys.

In 1872, the Denver City Water Company, under the direction of James Archer, was the first to offer indoor plumbing in Denver.

Letter deliveries in Denver were started on September 1, 1879. There were six letter carriers.

Carriage and wagon creator August E. Almberg claimed to be the first man to use the term "Made in Denver."

Regis University was funded in 1888 by Jesuit priests from Las Vegas, New Mexico. They purchased about forty acres in 1887 and immediately started construction.

Buffalo Bill Cody, who could be seen on the streets of Denver, complete with his "fringed coat" blowing in the breeze, often grumbled about the skyscrapers that were being built in 1910. He said, "I am not a sentimentalist, not at all, but every time I see the new massive steel frames of skyscrapers springing into the air, I cannot think of the time when a view of the foothills could have been obtained—and a good one too—from any point in the city."

The city built a two-story firefighting department on Lawrence Street and purchased a 2,100-pound bell whose peal could be heard around town. It was not long before the Denver firefighters had gained the reputation of being a professional outfit, one that was greatly appreciated by the insurance companies.

Before coins were minted in Colorado, a pinch of gold dust was considered to be worth twenty cents—more if the individual had long fingernails.

Troop A, Colorado Springs, poses below at 4:30 a.m. on the morning of 1887, just hours after passing through Denver after participating in the Meeker massacre.

In 1880, the world's largest silver cache, weighing a monstrous 2,054 pounds, was found in the Smuggler Mine in Aspen.

The east side of Denver had its own firefighting department: the Negro Company. It consisted of three African American men and their white captain. A natural rivalry existed between the fire departments as each tried to put its best foot forward, but on the night of March 23, 1894, that was all forgotten. The

The men of Troop A of Colorado Springs are thought to have traveled through Denver during the early morning hours following their involvement in the Meeker massacre. *Courtesy Special Collections, Colorado College.*

alarm sounded, and firefighters from various locations rushed to the scene at the St. James Hotel. The four brave men of the Negro Company had entered the burning building when a floor collapsed, and all four men lost their lives.

In 1889, Jennie Rogers's house of prostitution was considered the most famous in the Rocky Mountain region. Her bordello, the House of Mirrors, a two-story house at 1942 Market Street, was built with hush money from one of her clients she threatened to expose. It was an elegant house with sixteen bedrooms and four parlors, each beautifully furnished. Jennie had mirrors installed on the ceilings and walls, crystal chandeliers, opulent oriental rugs, a grand piano and a poolroom. When Jennie's health began to fail in 1908, she sold the house to her rival, Mattie Silks.

Blond bombshell Mattie Silks owned three brothels in Denver. As madam, she took a personal interest in how her girls looked, behaved and dressed. They wore beautiful dresses in the Medici style, and their hair was coiffed

People huddle on the sidewalk as one man walks down the center of the street. Cars are parked or abandoned. Some appear to be stuck during one of the many snowstorms to hit Denver during the 1920s. *Courtesy Denver Public Library.*

after the great Iroquois Confederacy and its democratic governing body. After the War of 1812, the name was changed to the Society of Red Men and in 1834 to the Improved Order of Red Men. They kept the customs and terminology of Native Americans as a basic part of the fraternity.

The Knights of Columbus opened Council No. 539 in Denver on November 18, 1900. The Knights were originally founded in 1882 in New Haven, Connecticut. Council No. 539 was the first council west of the Mississippi River. The council number is indicative of the order in which they were chartered. There are now more than sixteen thousand councils.

The first cheeseburgers were sold at the Humpty Dumpty drive-in on March 5, 1935.

From 1899 until 1933, twenty-four police officers lost their lives in the line of duty.

About the Author

Elizabeth Victoria Wallace was born and educated in England. In 1978, she moved from England to the United States with her husband and three young sons. Over the past ten years, she has published seven books that include works of regional history, travel and historical fiction. Wallace is very active in the community, giving workshops and seminars and attending conferences. She also supports the Gathering Place, a daytime shelter for women and children in Denver.

Wallace is the founding member of the Castle Rock Writers and a member of Denver Woman's Press Club and the Society of Women Writers and Journalists in London. She has appeared live on television and radio and is known as one of the "Word Mavens" of Kansas City for originating a monthly program on the local NPR affiliate that discussed the origins of everyday sayings.

Visit us at
www.historypress.net

This title is also available as an e-book